IMAGES
of America

FOSTER CITY

The Foster City logo was created by T. Jack Foster & Sons' advertising agency, Honig, Cooper & Harrington of San Francisco. It was later used on the masthead of the *Foster City Progress.* Designed prior to the completion of the first homes, the logo has remained unchanged to this day.

IMAGES
of America

FOSTER CITY

Foster City Historical Society
Foreword by T. Jack Foster Jr.

ARCADIA
PUBLISHING

Published by Arcadia Publishing
Charleston, South Carolina

Printed in the United States of America

Library of Congress Catalog Card Number: 2004105906

For all general information contact Arcadia Publishing at:
Telephone 843-853-2070
Fax 843-853-0044
E-mail sales@arcadiapublishing.com
For customer service and orders:
Toll-Free 1-888-313-2665

Visit us on the Internet at www.arcadiapublishing.com

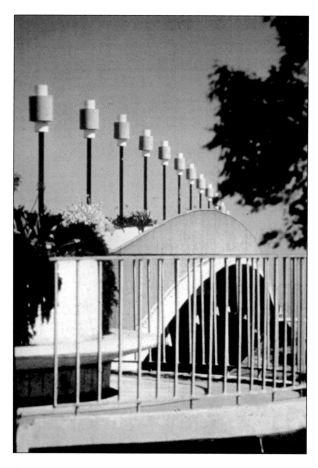

The Hillsdale Bridge, featuring its distinctive "string of pearls" lighting, leads from San Mateo into Foster City. (Courtesy of the Foster City Chamber of Commerce.)

CONTENTS

FOREWORD

In the 19th century, it was a shallow part of San Francisco Bay adjacent to San Mateo. It was covered by bay water at high tide, and, like most of the area extending southward, thousands of acres were exposed to the air when the tide ebbed. They were called "mud flats," and the mud extended to a depth of well over 50 feet. At the beginning of the 20th century, Frank Brewer acquired ownership of the land and floated a municipal bond issue for the purpose of constructing levees completely around the perimeter, a distance of six miles. As the tidal flow was cut off, the exposed mud began to dry, and in a short time, Brewer planted hay for his dairy cattle. With the levees separating it from the mainland, it was, effectively, an island. Folks began to call it Brewer Island.

Foster City's history started in 1960 when my father exercised the option to buy 2600 acres of Brewer Island for the purpose of building a new town. Without any further consideration or doubt about its ultimate success, he said, "We will call it 'Foster City.'"

As his eldest son, I moved from Hawaii with my young family to assume the role that he had for me of being the General Manager of Development. I was 32 years old and excited at the prospect. Those ensuing years were the most vital and dramatic years of my life.

Money was readily available and costs were inexpensive. There was a gung-ho spirit in the land and the support for development of this huge, vacant parcel of land was widespread. Early homebuyers bought into the dream and put up with the blowing dirt, noise, construction traffic and other inconveniences of building. I marvel at how many of the "pioneers" chose to remain in Foster City rather than to move on to older, established communities.

I have seen the community grow up and mature. I have seen the enormous pride of ownership evident all over the city. I have often been asked if I am not surprised at how well it turned out. I have to say, "No, I am not—our aspirations were very high." Then I add, "But I am very pleased."

I am grateful that I was young when it started so that I can be around to see its history evolve. This book of photographs will remind us of what has ensued these past 44 years since conception, and 33 years since incorporation as a city.

—T. Jack Foster Jr.

INTRODUCTION

Mention the history of Foster City, and one immediately thinks of a time that is still etched in the recent memory of many people. But in truth, the story of Foster City actually begins back in 1901, when a dairy rancher by the name of Frank Brewer purchased a tract of land in San Mateo. The land was separated from San Mateo proper by a strip of water known as Marina Lagoon. Brewer installed levees in the lagoon and drained the island for use in grazing his cattle, and several years later, sold the island to the Leslie Salt Company for use as an evaporating pond.

Fast forward to 1958. The hula hoop was the latest craze, a 707 flying from New York to Miami ushered air travel into the jet age, and a man named T. Jack Foster had a vision to create a new community located between the cities of San Francisco and San Jose. A successful real estate developer, Foster had overseen the construction of residential developments in California, Hawaii, Texas, and Oklahoma. Although he had recently retired from the real estate business, he soon found that retirement was not to his liking and decided to undertake one final project that he and his three sons could work on together. After surveying several sites from Monterey to Sacramento, Foster decided on a tract of land known as Brewer Island, located about 20 miles south of San Francisco. Foster had a vision to transform this 2,600-acre hay and mud pile into a successful planned community, the first of its kind on the West Coast. His plan called for specific parcels to be zoned for parks, shopping centers, schools, and houses of worship, while the remaining tracts were to be developed for residences and businesses. In an April 18, 1969 radio interview on KNEW, T. Jack Foster Jr., the son of the developer, said this of his father's vision:

> We saw this large piece of land consisting of about four square miles and decided what might be done with it. Our research led us to the conclusion that an entire new town might be created here with homes and apartments and industry and shopping centers

There was only one problem: Brewer Island was just that—an island whose soft mud could not possibly support the weight of an entire city's worth of buildings. Furthermore, its elevation was such that it would easily flood in a winter storm. To rectify both problems, consulting engineers Wilsey, Ham & Blair recommended filling the island to an elevation of six feet and creating a central lake where water could be collected, held, and later pumped back into the bay. Thus, out of practicality, was born one of Foster City's most pleasing aesthetic features—its 16 miles of navigable waterways and lagoons.

As America grew in the 1960s, Foster City grew with it. The first homes were completed by 1963, and the "pioneer" residents began moving in that same year. Prices ranged from $21,950 for a three-bedroom home to upwards of $40,000 for waterfront property. By 1964, the waiting list for homes in Foster City contained no fewer than 2,000 names. But the new community was not immune to the political climate of the 1960s either. At the time of its founding, Foster City was considered an unincorporated suburb of San Mateo, but its property taxes were the highest in the county. Not content to see his new town treated as "San Mateo's step-sibling," Foster and the city leadership fought hard to emancipate themselves from San Mateo's government. After

a five-year battle, Foster City was incorporated on April 27, 1971 as the newest community in San Mateo County. Following its incorporation the city went though a period of political instability, hiring no fewer than 13 city managers between 1971 and 1977, with four different managers in 1971 alone. Since 1977, however, the city leadership has been strong and stable, a fact that can be seen in the increase of property values and growth in population.

Throughout the 1980s, the city continued to grow and change, establishing itself as a thriving business center between Silicon Valley and San Francisco. New companies in the emerging field of biotechnology began basing themselves in Foster City, and in 1986, the city's first skyscraper, the Metro Center, opened its doors, as did the city's first hotel, the Holiday Inn. Change continued in the 1990s, with the opening of a new library, recreation center, fire department, and most recently, the City Hall complex.

Foster City is unique among Northern California communities in that it is a living history; many of the city's "pioneer" residents still live in the same houses and have borne witness to the many changes in the city. To speak of the history of Foster City is to speak of a modern marvel and what can come from the successful marriage of city planning and engineering. Foster's original master plan called for a population of 35,000 and a completion date of 1976. Foster City is far from "complete," and continues to grow and change as it looks to the future. T. Jack Foster would truly be proud.

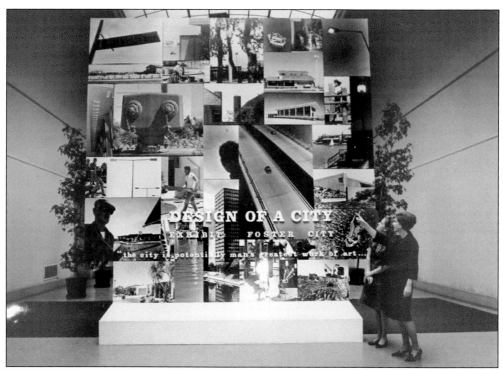

By invitation of the San Francisco Museum of Modern Art, a major gallery exhibit entitled "Design of a City: Exhibit Foster City" was presented in 1965 from October 22 to November 21. The exhibit showcased the new and growing peninsula town, and displayed street name signs, street lights, and fire hydrants, as well as a scale model of the city and information about residences, bridges, and neighborhood parks. (Courtesy of Foster Enterprises.)

One

THE VISION

A vision has to start with something, and that something was Brewer Island. Originally, this land was only barren marshland located on the San Mateo County Coast near the then small town of San Mateo. In fact, during the 1870s and 1880s, the most prominent features in the environs were the oyster houses that sat above the water in the bay off of the land, one of which included the San Mateo House, right off of Little Coyote Point (which would become the site of the original San Mateo bridge toll booth some 45 years later). In 1898, Mr. Frank Brewer purchased the land to construct a barn, wells, windmill, and roads for his dairy farm, which he maintained until 1905. In 1900, he erected levees and dikes to reclaim some 2,000 acres and stop the tidal flows. The area quickly took on his name and was called Brewer Island. Leslie Salt Company acquired portions of the land and constructed salt ponds for commercial use. Leslie later leased the lands to dairymen and farmers who raised hay and oversaw grazing cattle. Also during this time, Brewer Island acquired a reputation as an area for duck hunting along the sloughs. In 1947, construction started on a protective facing for the levees that offered excellent protection against the wind and tides. The end of this construction effort led right into the beginning of incredible and dramatic changes that would forever alter the nearly inconspicuous Brewer Island.

There is no denying that T. Jack Foster Sr. was a visionary. From his humble beginnings in Texas as the youngest of 11 children to his emergence as a real estate magnate in the 1960s, Foster brought foresight, innovation, and good, old-fashioned business sense to everything he did, including the development and establishment of the newest town in San Mateo County.

T. Jack Foster Sr. was born in 1902 in Mineral Wells, Texas. Orphaned at the age of five, he was raised largely by his siblings and his extended family. Even as a child, T. Jack Foster Sr. showed a developing entrepreneurial spirit, expanding a paper route into a "newspaper distribution business" that eventually employed other neighborhood children as newspaper carriers. Pleased by the amount of money he was making, T. Jack dropped out of high school in the hopes of opening his own business, but his family soon convinced him that his lack of a solid education would prove problematic in the future. On the urgings of his family and siblings, he

9

applied to and gained admission to the University of Oklahoma, even without a high school diploma; while there, he opened his first business, a cleaners on the university campus. Once again, though, his entrepreneurial spirit cut into his education and he dropped out of school to run the business. A few years later, though, he would enroll in law school, during which time his family grew with the birth of T. Jack Jr., followed by John (Bob) and Richard (Dick), all three of whom would later participate in their father's biggest project, the founding of Foster City.

Throughout the years, T. Jack Foster Sr. would hold various positions, including mayor of Norman, Oklahoma, and Norman city attorney (he was admitted to practice at age 26), but it was his interest in city planning and construction engineering that would serve him in his future endeavors. At the end of World War II, Foster went into pumice mining in New Mexico where he discovered that this mineral could be used to produce a fireproof concrete; it was this endeavor that launched T. Jack Sr. on the road to home building. Foster began constructing residential developments in California, Texas, New Mexico, Kansas, and Hawaii, including the 25-story Foster Tower in Honolulu. During his time in California, Foster fell in love with the Monterey Peninsula and decided to retire there with his wife in 1958. It soon became evident to T. Jack that the retired life was not for him and decided to emerge from retirement for a final, climactic project on which his entire family could work. The Fosters scoured Northern California from Sacramento to Monterey before deciding on the parcel of land in San Mateo known as Brewer Island. Here, he realized, was the ideal place to build a new city. On August 25, 1961, a formal groundbreaking was held for construction of the new city.

T. Jack Foster Sr. passed away on March 15, 1968, but not before seeing his dream of a new city become a reality. Through a combination of luck and good business sense, T. Jack Foster Sr. built a legacy that still stands and continues to grow with each individual that moves in to his namesake city.

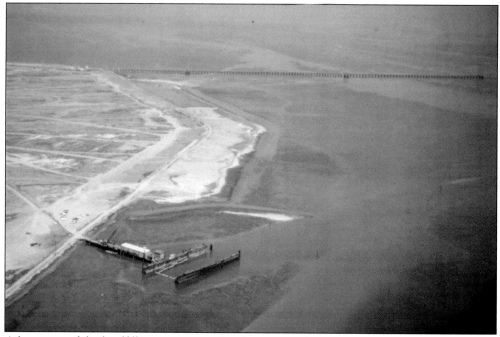

A key point of the landfill operation was this drop station located along Beach Park Boulevard, c. 1963. (Courtesy of the Foster City Chamber of Commerce.)

In this 1868 San Mateo county map, a salty marshland on the bay is shown. The map was actually printed upside down, with due south at the top and due north at the bottom. These so-called creeks were really only tidal sloughs in the marshlands. Angelo Creek, seen in the upper middle portion of the map, roughly defines the southern border of the present Foster City. The point on the far left, a little more than halfway down, is called Little Coyote Point, where later would stand the original San Mateo Bridge tollbooth. The winding creek (seen at the left side of the map), later to be known as Seal Creek, would roughly define the northern border of Foster City. The then small town of San Mateo lies at the bottom of the picture. This area would remain crude until it was diked in 1901. Marina Lagoon (once called Seal Slough) now separates Foster City from San Mateo, and Belmont Slough buffers Foster City from Redwood Shores. (Courtesy of San Mateo County Archives.)

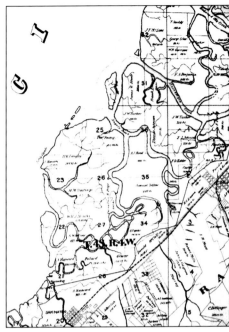

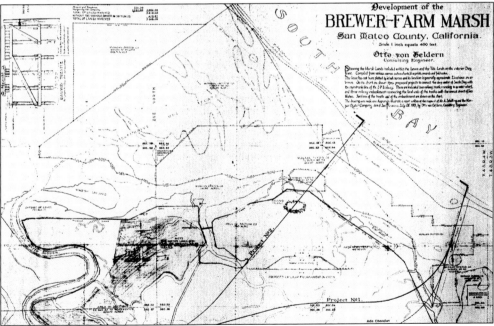

This chart, showing the Brewer Island Marshlands included within the levee and tidelands, is based on a diagram by Otto von Geldern, consulting engineer for San Mateo County in 1915. The levee has not been plotted by actual courses and its location is approximate. Three proposed projects can be seen on this chart to connect the deep water of South Bay with the main trunklines of the Southern Pacific Railway. Two railway tracks running to the outer wharf and three railway embankments connect the land ends of the trestles with the nearest street of San Mateo. Sections of the trestle and of the embankment are also shown on the chart. (Courtesy of Wilsey, Ham & Blair Engineers and Planners.)

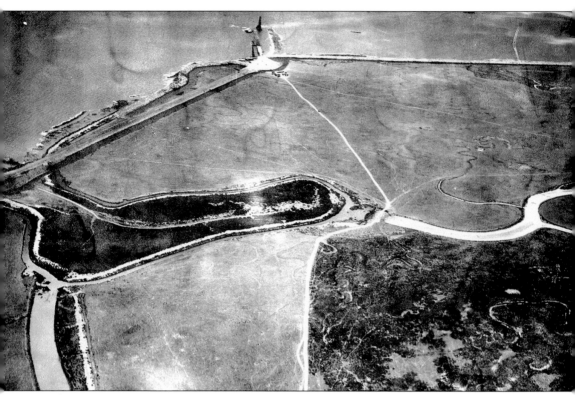

This image depicts the commencement of construction of the San Mateo–Hayward Toll Bridge, c. 1925. The road extended from a Southern Pacific Railway Station in Salt to a loading facility at the present tracks and what was then 19th Avenue. The present 19th Avenue–Park subdivision was once a series of salt evaporation ponds, later filled in by L.C. Smith Paving Company. (Courtesy of Richard Grant.)

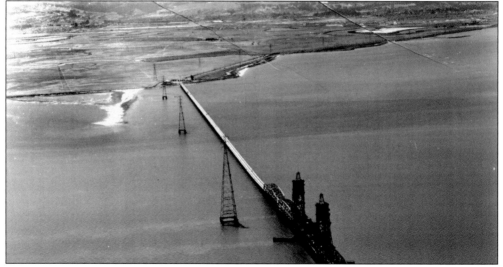

Taken on July 21, 1954, this picture shows the Third Avenue approach along Brewer Island to the old San Mateo Bridge. The Thierkelsen Ranch, formerly the Frank Brewer Dairy Ranch, is clearly visible on the island. (Courtesy of Caltrans Library.)

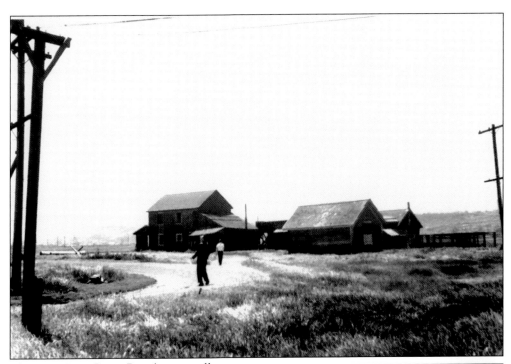

The San Mateo Dairy Ranch, originally constructed by Frank Brewer and later purchased by the Thierkelsen family, is pictured here in 1962. The structure on the left is the barn with individual dairy houses seen on the right. Brewer was responsible for having the original marshland diked in 1898 for the construction of his dairy farm. This would have been located just north of present-day Hillsdale Boulevard off of Edgewater in what is now Mariners Island. (Courtesy of David McKean.)

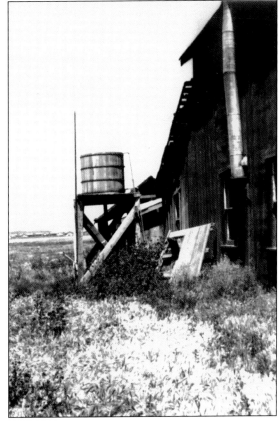

This is a close-up view of the water tower located behind the barn. Interestingly, the only water that ran here during the time that Brewer built his ranch was water found in the sloughs. This was brought in and used specifically for the dairy cattle. Looking straight ahead from the water tower, the Shoreview area of San Mateo is visible. Coyote Point can be seen just beyond and above Shoreview. (Courtesy of David McKean.)

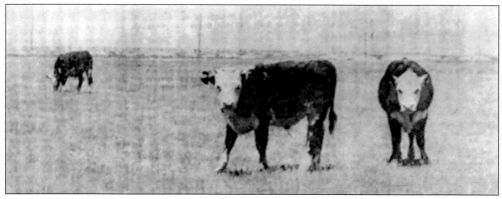

Cattle graze on Brewer Island prior to the Foster City groundbreaking in 1961. During this time, some 1,726 acres of the land were used for grazing and about 900 acres for salt evaporating ponds by the Leslie Salt Company. (Courtesy of the *Burlingame Star Registry*.)

The mud in Brewer Island appears hard and cracked with some vegetation already growing. (Courtesy of David McKean.)

T. Jack Foster Sr. was interested in one last major development project somewhere on the California Coast; leading him eventually to Brewer Island. Foster, along with Richard Grant, another major developer, took an option to purchase Brewer Island in 1958 from the Schilling Estate Company. This was the beginning of Foster's dream to eventually see a full-fledged, thriving community emerge from this nearly forsaken island. Foster acquired the Grant interest prior to exercising the option in August 1960. (Courtesy of the Foster family.)

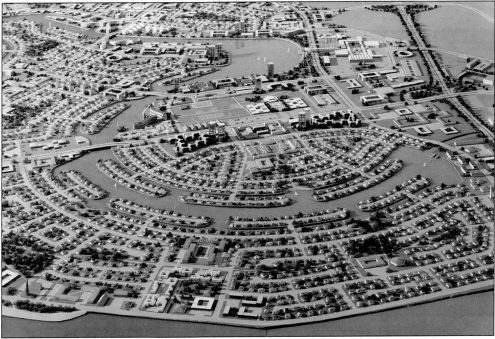

This is a scale model of Foster's planned community. Although the ultimate development differs somewhat from the mode, many similarities between it and present-day Foster City do exist, including the central lagoon and the seven neighborhood islands. (Courtesy of Kenneth Miskow.)

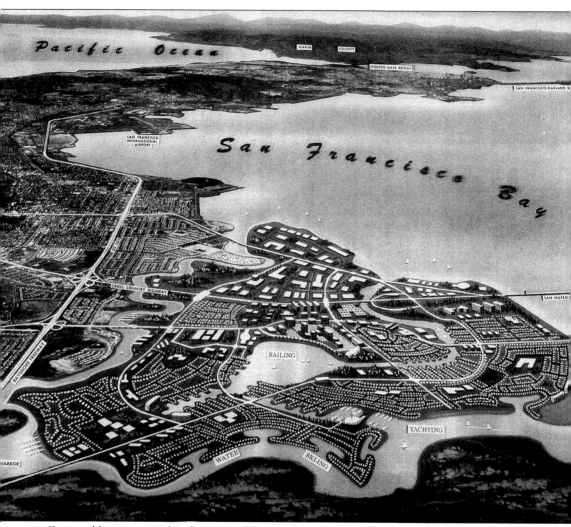

Depicted here is an early schematic of Foster City's future look. T. Jack Foster Sr.'s vision was to reach completion by 1976, with an anticipated population of 35,000 housed in 5,000 single family homes, 1,600 townhouses and 4,400 apartments and condominiums, divided into nine neighborhoods. The master plan called for one elementary school for each of the nine neighborhoods, two middle schools, and one high school. Currently, just three elementary schools and one middle school exist. The high school was never built, but a charter high school effort is currently in the planning stages. (Courtesy of Kenneth Miskow.)

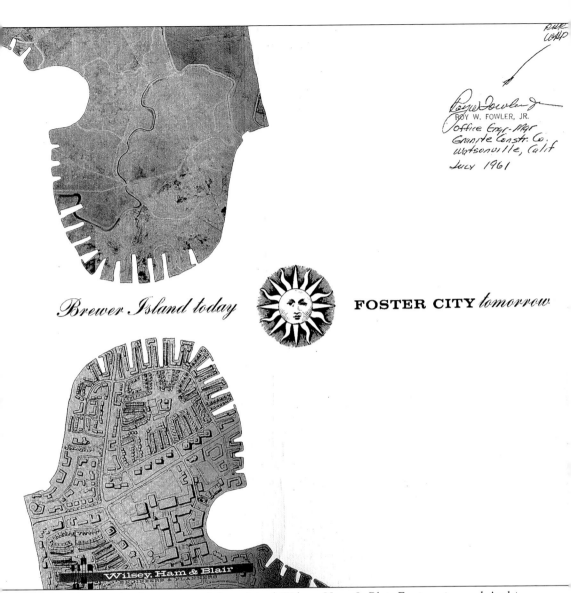

Brewer Island today FOSTER CITY *tomorrow*

Wilsey, Ham & Blair
ENGINEERS & PLANNERS

Pictured here is the front cover of the original Wilsey, Ham & Blair Engineering and Architectural report from July 1961, detailing feasibility studies relative to Foster City's engineering, finance, residential, commercial, recreational, and public use dynamics. Note the transitional slogan, "Brewer Island Today, Foster City Tomorrow" and the comparative photographs. (Courtesy of Wilsey, Ham & Blair Engineering Associates.)

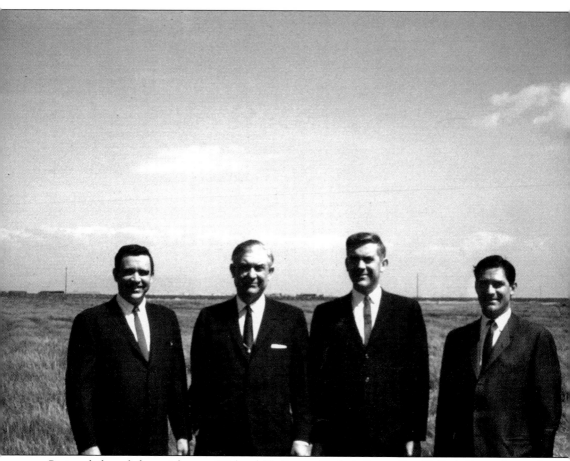

Pictured, from left to right, are Richard H. Foster, T. Jack Foster Sr., T. Jack Foster Jr., and John R. (Bob) Foster. T. Jack Foster was born in Texas in 1902 and was raised by his siblings after their parents passed away. A self-made millionaire, Foster enjoyed a long career as a banker, real estate developer and entrepreneur. He retired to California in the late 1950s after working on a housing project at Fort Ord. Because of his abundant energy, Foster soon emerged from retirement, and with a pioneering spirit and his three sons, set his ambition towards a new development of a master-planned community on Brewer Island. (Courtesy of the Foster City Chamber of Commerce.)

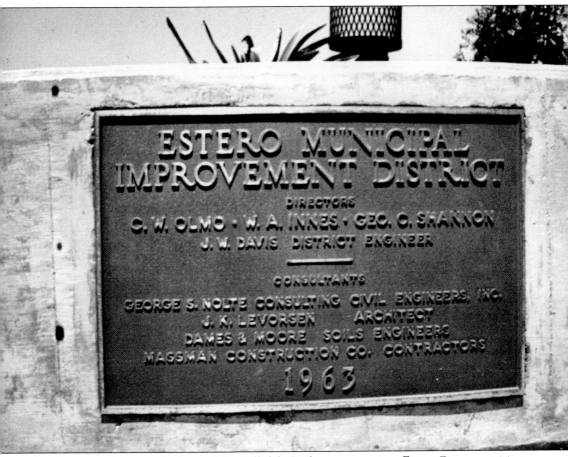

Seen here is a plaque at the base of the Hillsdale Bridge entrance into Foster City recognizing the Estero Municipal Improvement District. Because the idea of Foster City was conceptually innovative, some doubted its success, and consequently, the Fosters found it difficult to obtain private financing. In 1960, the State of California formed the Estero Municipal Improvement District to provide and operate the municipal services and facilities needed for the new town, such as police and fire protection, refuse disposal, water supply, sanitary sewage, street lighting, etc. The Estero Municipal Improvement District was instrumental in assisting Foster City's growth prior to the city's 1971 incorporation. (Courtesy of the Foster City Chamber of Commerce.)

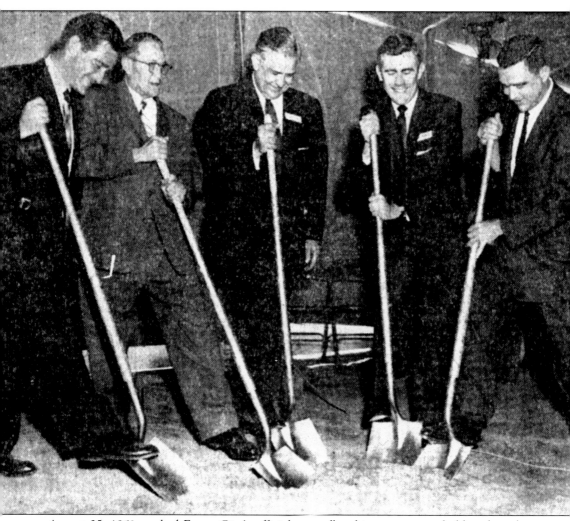

August 25, 1961 marked Foster City's official groundbreaking ceremony, held under a huge tent erected on Brewer Island. Pictured here turning over the first shovel of earth are, from left to right, J.R. Foster, supervisor Edward R. MacDonald, T. Jack Foster Sr., T. Jack Foster Jr., and Richard Foster. Other participants not shown in the picture included George Shannon, district manager of the Estero Municipal District Board; William Innes, director; John Davis, district engineer; A.O. Champlin, controller; Kenneth McCallum, building superintendent; Chris Olmo, director; Ralph E. Chase, office manager; and H.E. Hubbard, assistant. (Courtesy of *San Mateo Times*.)

Two

THE ISLAND OF
THE BLUE LAGOONS

Even before the shovels broke ground in 1961, T. Jack Foster Sr. had done immense studies to determine the feasibility of building a new city from the ground up. The studies ranged from such basics as determining where to erect what types of buildings to analyses of soil samples in order to find the best material for filling in the land. The choice of filling material was particularly important as sinking and settling would be major concerns for a city built on reclaimed land. After analyzing borings from all around the bay, T. Jack Foster and Richard Grant decided that the most suitable filling material was hydraulic sand, a huge deposit of which was located just north of the San Francisco Airport in an area known as San Bruno Shoal. The hydraulic sand would be dredged up from the bay, deposited onto specially constructed "dump truck" style barges, and then transported by tugboat down the peninsula into a receiving area located across the street from what is now Beach Park Boulevard. The deposited sand and mud were then graded and pumped through pipes where it could be deposited to any location on the island.

Because the city was constructed on reclaimed land, Lee Ham, one of the partners in the Wilsey-Ham engineering firm, placed great emphasis on the importance of drainage. Ham worried that the city would either sink or be washed away in the event of a major storm. To prevent this disaster, the city would require a specially designed "water impoundment facility" where excess water would collect before being pumped back into the bay. According to Ham, this "drainage basin" would be approximately six-feet deep in the summer and four-feet deep in the winter with no part of the city further than 1,110 feet from the lagoon; thus one of Foster City's most appealing features—its waterways—was born out of necessity rather than aesthetic value. In spite of Foster's careful research and planning, naysayers continued to claim that in the event of a major earthquake or a severe winter storm, Foster City would either sink into the mud or be washed away like river detritus. Foster's foresight and research in this area would later prove invaluable. Foster City escaped nearly unscathed during a so-called "100-year storm" in 1982, while other higher lying communities were flooded. Seven years later, during the Loma Prieta earthquake, Foster City once again emerged without destruction, though the Marina District of San Francisco, also built on filled land, sustained major damage.

Foster's master plan called for a maximum population of 35,000 and an estimated completion date of 1976; residents would be housed in 5,000 single-family homes, 1,600 townhouses, and 4,400 apartments. The city would be divided into nine self-contained neighborhoods, each with an elementary school and a park, not unlike the layout used in many cities in Europe. Land consisting of 230 acres would be zoned for parks and lagoons while 40 acres would be reserved for houses of worship. The outskirts of the city would be zoned for commercial and industrial use while an area close to the bay would be reserved for specific use as a boat marina. In the mid-1980s, due to environmental concerns, plans for a marina were scrapped and the area was turned over to developers to be made into new neighborhoods. A portion of the marina parcel remains as open space and a jogging trail.

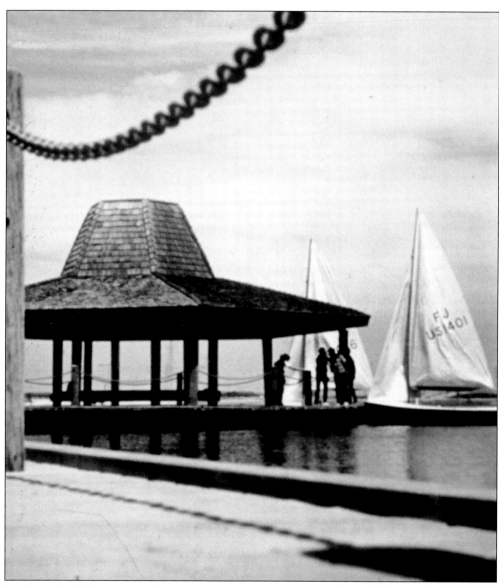

In this mid-1960s photo, sailboats are docked at the Central Park gazebo. (Courtesy of the Foster City Chamber of Commerce.)

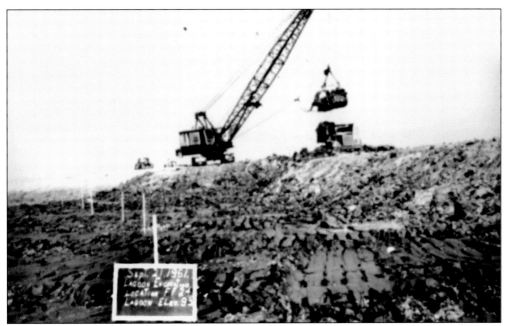

Originally, the issue of drainage led to the proposal of utilizing a basin to dispose of rainfall, which further led to the solution of a lagoon. Moreover, developing a lagoon system to collect storm water would not only enhance the city's appearance but afford its new residents an aquatic playground as well. Part of the lagoon excavation effort is shown in this September 21, 1961 photo. In all, 2.5 million cubic yards of material would be excavated by November 1964 to make the lagoons a reality. To capture the image of residential homes surrounded by aesthetically pleasing waterways, the slogan "Foster City—The Island of the Blue Lagoons" was later coined. It is no wonder that Foster City has often been likened to the great European city of Venice. (Courtesy of the Foster City Chamber of Commerce.)

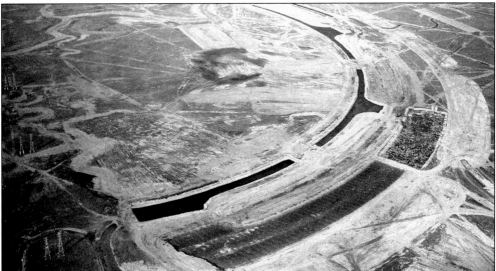

This aerial photograph from 1962 shows the master-planned community in its very early stages with the first islands, notably Flying Mist and Shooting Star, beginning to take shape. (Courtesy of the Foster City Chamber of Commerce.)

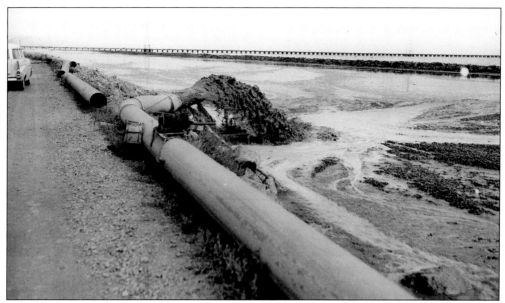

In 1961, a massive hydraulic fill operation began in earnest to raise the level of Brewer Island by several feet. Land fill totaling 18 million cubic yards of sand was dredged from San Francisco Bay, then pumped and spread onto and across the existing terrain through an extensive pipe system. Inspect a handful of Foster City dirt today and chances are that shells once residing beneath the bay can be found —a reminder of what it took nearly five decades ago for T. Jack Foster to realize his dream of a bayside, master-planned community. (Courtesy of the Foster City Chamber of Commerce.)

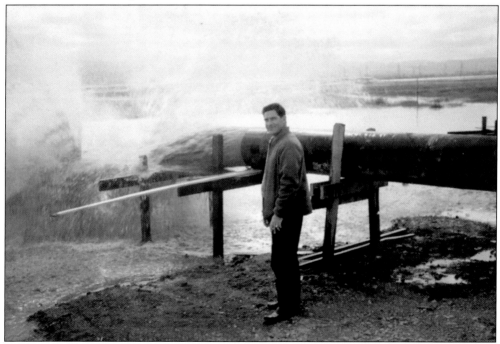

Bob Foster views the hydraulic fill operation, where the dredged material was pumped through a 24-inch-diameter line to a fill site. (Courtesy of the Foster City Chamber of Commerce.)

24

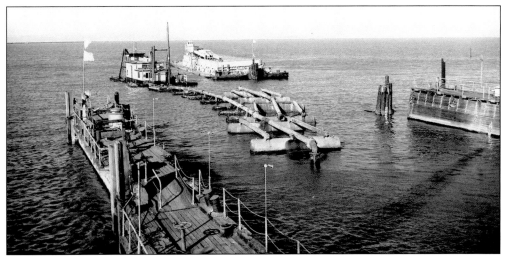

Pictured here is one of several float and pump mechanisms used in the hydraulic filling process, anchored just off of present-day Beach Park Boulevard. Some remnants of wooden support equipment are still visible today. (Courtesy of the Foster City Chamber of Commerce.)

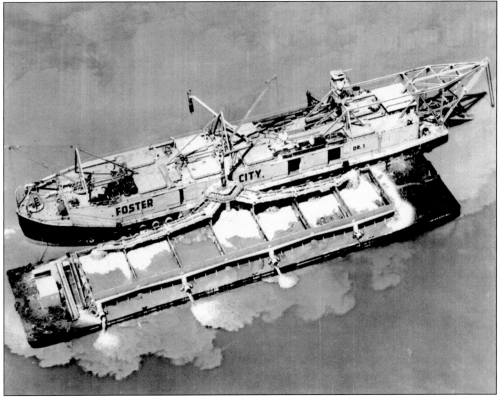

Seen here is one of the two barges used to transport the sand dredged from the bay to the fill sites. It took about two and a half hours to load a barge to a capacity of 1,500 cubic yards of dredged material. Once loaded, the barge then took 45 minutes to travel to Brewer Island from the dredging site just north of San Francisco Airport, an area called San Bruno Shoals. (Courtesy of Catherine Miskow.)

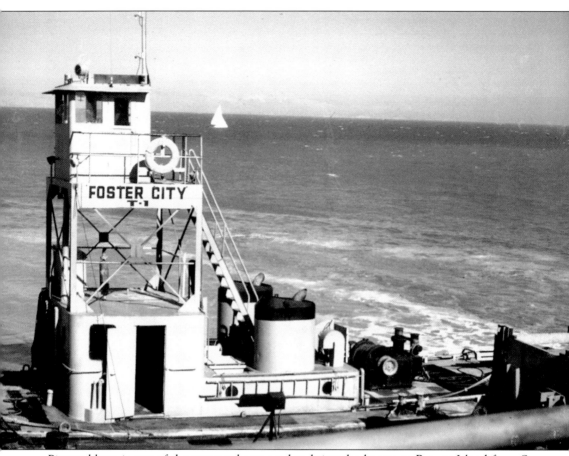

Pictured here is one of the two tug boats used to bring the barges to Brewer Island from San Bruno Shoals. (Courtesy of the Foster City Chamber of Commerce.)

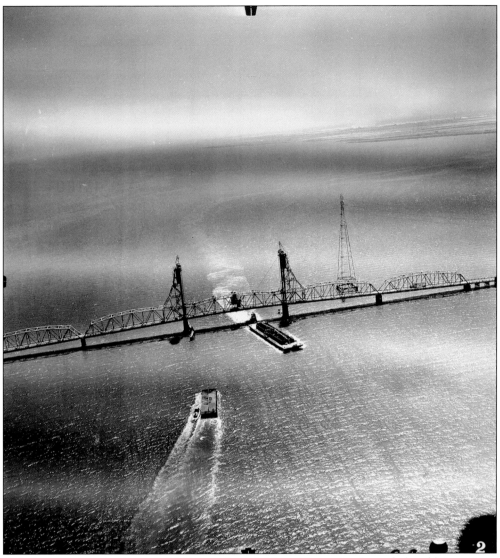

A daily occurrence in the early 1960s was that of ship traffic passing *beneath* the old San Mateo Bridge. Tugboat and barge (foreground) head toward Brewer Island, while the vessels at the center are returning from the fill site to San Bruno Shoals. Brewer Island can be seen in the background, above and to the right. (Courtesy of the Mooney family.)

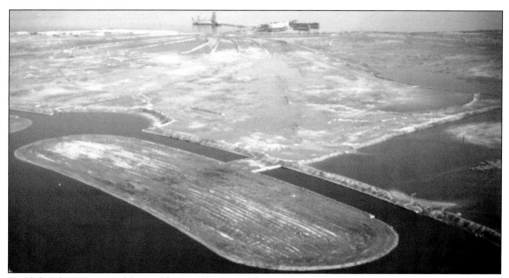

Sailfish Isle is pictured here during filling. At this stage of the dredging and fill process, areas were driven over by tractor trucks in order to drain the water and compact the fill, then the areas were left to "mature" prior to development. In many cases, retaining dikes had to be constructed so that solid material could be deposited and water would then flow to an auxiliary pump. Prior to bringing hydraulic fill into an area, it was necessary for all existing sloughs to be filled and compacted. The fill drop sites are in the background along what is now Beach Park Boulevard. The land in between, now neighborhood three, shows an area freshly filled and noticeably ongoing. What would later become Marlin Park is seen just left of center. (Courtesy of the Mooney family.)

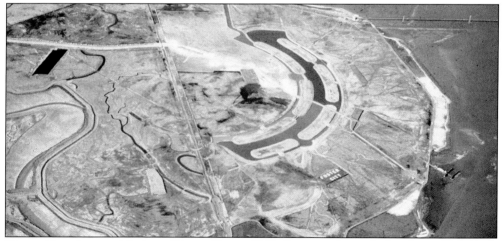

Pictured here is an aerial view of Foster City c. 1963. Compare this with the photo on page 23. Visible in this photograph are the islands that would later become Flying Cloud Isle, Flying Mist Isle, Shooting Star Isle, Surfbird Isle, Shearwater Isle, Dolphin Isle, and Sailfish Isle. The large, central lagoon had yet to be constructed, as did many of the smaller waterways. The city's two main arteries, the north-to-south Foster City Boulevard and the west-to-east East Hillsdale Boulevard, are visible as dirt roads. Note the Foster City sign in the lower right, and the presence of a dirt bridge connecting the two furthest islands. The bridge was built to allow construction vehicles to move easily from one island to the next. No such bridge between the islands exists today. (Courtesy Shawn Mooney.)

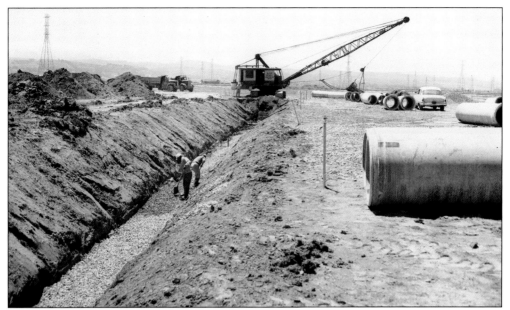

Constructing Foster City required piecing the city's infrastructure together, pipe by pipe, in the early 1960s. The facilities that regulated the lagoon levels were all built along Third Avenue including the city's sewage treatment plant, a four million gallon water storage tank, and a pumping control station. (Courtesy of the Foster City Chamber of Commerce.)

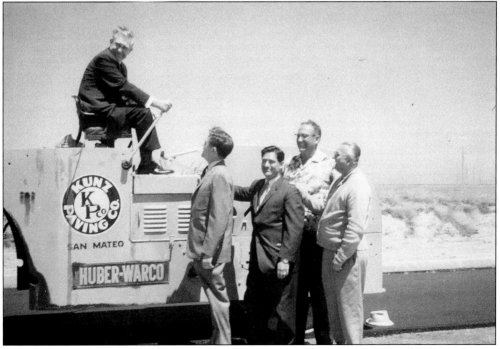

Paving the way to his dream. T. Jack Foster Sr., is pictured here atop a roller helping pave one of Foster City's first streets in 1963, along with, from left to right, T. Jack Foster Jr., Bob Foster, and two unidentified Kunz Paving Company partners. (Courtesy of the Foster City Chamber of Commerce.)

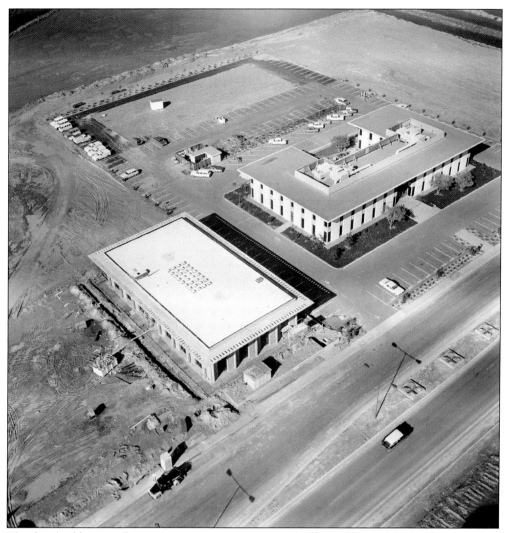

The first buildings in Foster City were two commercial efforts; The Wilsey & Ham Building (right), completed in early 1964, followed shortly thereafter by the Foster Building (shown under construction, left). The Wilsey & Ham Company had relocated from Millbrae, as they were principal engineers in the venture. The next-door twin of the Foster Building would later house Wells Fargo Bank and was completed in 1965. (Courtesy of the Foster City Chamber of Commerce.)

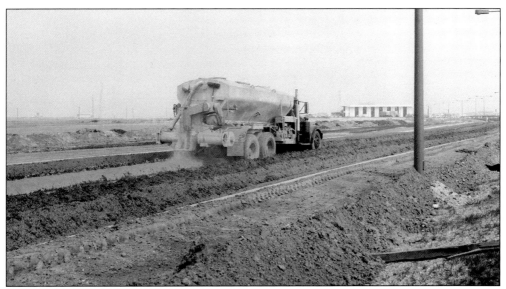

Grading of the landfill is seen here in preparation for full-scale commercial and residential development. Now one of the city's busiest streets, East Hillsdale Boulevard is being prepared for paving in this 1964 photo, with the Foster Building in the background. (Courtesy of the Foster City Chamber of Commerce.)

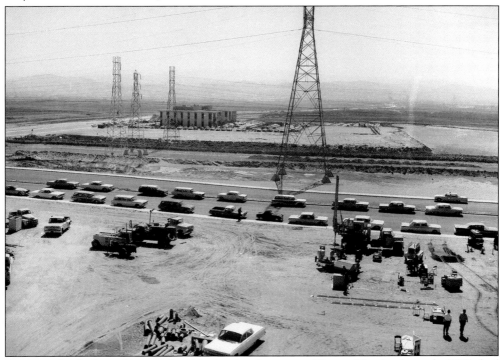

Anyone who had anything to do with the development of Foster City in the early 1960s had no trouble finding parking, as seen in this image from Foster City Boulevard near East Hillsdale Boulevard. It was at this intersection that Foster City's first retail business later opened, a 10-pump Standard Oil Company service station, in the spring of 1965. (Courtesy of the Foster City Chamber of Commerce.)

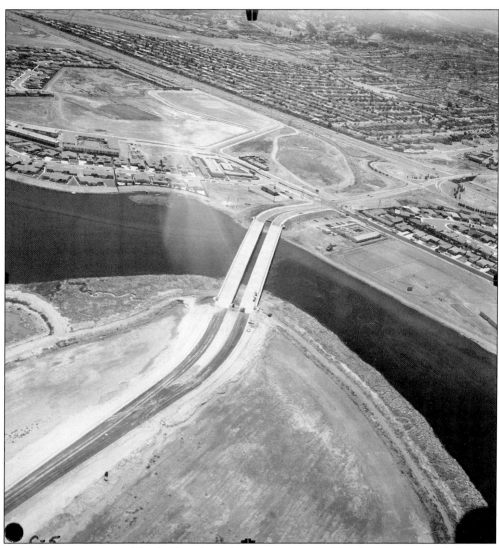

Until the construction of this bridge, the only access to Brewer Island was along Third Avenue. As the development effort continued, a second access point was constructed at East Hillsdale Boulevard near Norfolk Boulevard in San Mateo. This 1963 picture shows the Hillsdale Bridge nearing completion. Contrast the development of the San Mateo Village area west of Highway 101 against the barren west end of Brewer Island pictured in the foreground. (Courtesy of the Mooney family.)

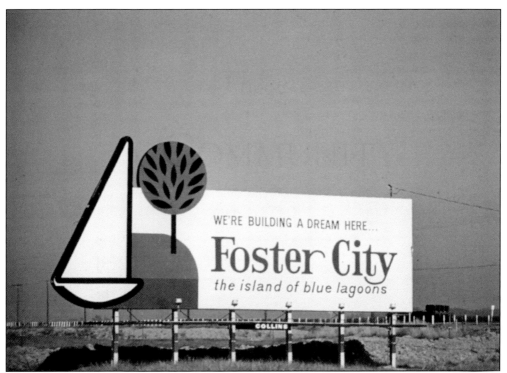

Signs advertising the development of Foster City were a common sight along Third Avenue and east of Highway 101 in the 1960s. The sign above introduced the city's logo and its slogan, "The Island of Blue Lagoons." The lower sign indicates to prospective residents that model homes were open and pioneers were welcome. (Photos courtesy of the Mooney family.)

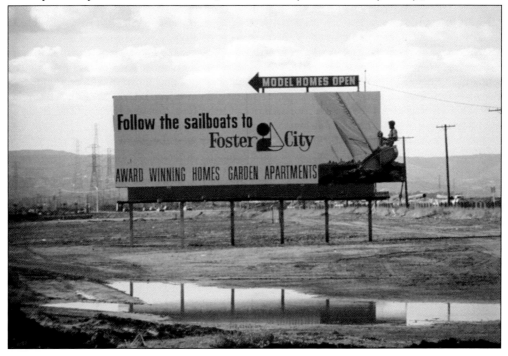

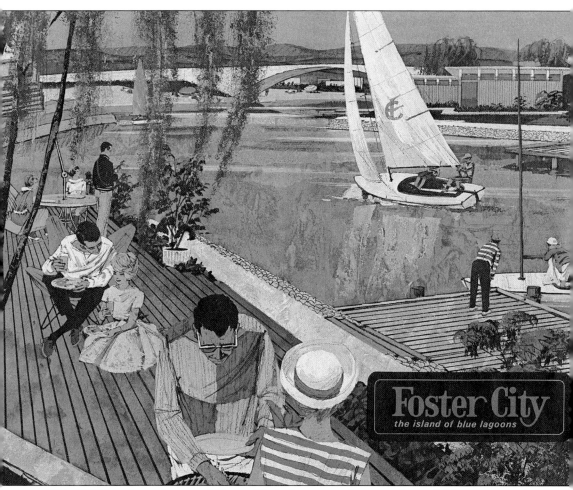

This 1963 brochure showcased Foster City's features and was made available to prospective residents at the sales offices located within the earliest housing developments. At the time, only a few model homes existed, so Foster City's marketing and promotional materials were limited to artist renditions of what was to come. (Brochure courtesy of Leo Duerr.)

Three

A COMMUNITY
TAKES SHAPE

When the first residents began arriving in the early 1960s, the city was essentially still under construction. The nearest grocery store was across the lagoon at the Los Prados shopping center in neighboring San Mateo. Salt marsh animals, such as field mice and jackrabbits, would frequently infest houses. Ambient noise from construction equipment was omnipresent. But perhaps the most annoying were the sand storms that would spring up every afternoon when the wind blew through the city; residents reported the paint being stripped from their cars and as much as a foot and a half of sand piled up on the front door step. One resident recalls that during these winds, there was no way to open the door without having sand spill into the house. Yet, despite these living conditions, pioneers continued to flock to the new city. New home prices ranged from $21,950 for a three-bedroom home to approximately $40,000 for waterfront property. The Fosters would sell undeveloped lots to future residents, and by 1965, there was a waiting list 2,000 names long to buy homes in Foster City.

Foster wanted to promote diversity among the design of homes in his new city, so he invited several different builders to submit plans. Among those whose designs were showcased in early Foster City were the open interior patio Eichler homes, the traditional split-level, five-bedroom homes of Duc and Elliot, and the Kay homes (later K&B Builders) with their very popular "ranch" style. Additionally, Foster ordered the construction of 12 "custom homes" including the so-called "Captain's House," a promotional name given to the first waterfront custom home. Even the townhouses and condominiums were designed to the highest architectural and aesthetic standards. The "Whaler's Cove" complex received the prestigious *Sunset Magazine*'s Western Home Award while "The Islands" won a 1976 Award of Excellence from *Architectural Record* and an Award of Merit from the American Institute of Architects and *House and Home* magazine.

Being a community on the water, it is appropriate that Foster City name its streets after all things nautical. According to legend, T. Jack Foster Sr. harbored a fascination with anything nautical and maritime, and this fascination was reflected in the naming of the city's streets. Neighborhood one featured the names of famous ships, such as the *Bounty*, the *Flying Mist*, and the *Balclutha*; neighborhood two streets were named after shorebirds, such as the Plover, Gull, and the Sandpiper. In neighborhood three, one finds the saltwater fish, such as the Marlin, the Halibut and the Shad; neighborhood four features boats and boat parts, such as Catamaran Street and Hull and Rudder Lanes. Neighborhood five featured famous explorers—DeSoto, Vespucci, and Cortez, to name a few, while neighborhood six streets took their names from naval heroes such as Halsey, Nelson, and Nimitz. Neighborhood seven featured the names of small islands; such as Pitcairn, Aruba, and Trinidad. Neighborhood eight featured names of bays like Biscayne and Pensacola. The last neighborhood has its streets named after stars and constellations, used by sailors to navigate before the advent of modern technology. Even the streetlights were specially designed to fit the nautical theme, with a "fin" structure rumored to replicate either a paddlewheel on a steamship or the fins on the back of a fish. These streetlights were unique to Foster City and remained in place until the late 1980s when they were replaced with standard light fixtures.

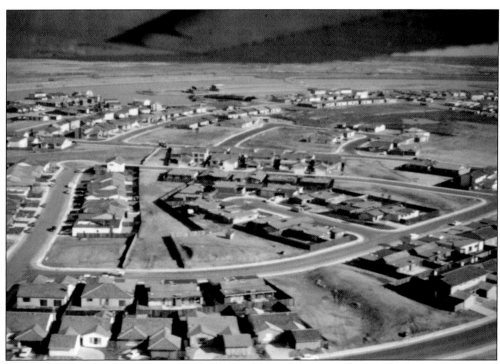

Pictured during development in 1965, Pilgrim Drive, Harvester Drive, Challenge Court, and other streets within neighborhood one. (Courtesy of the Foster City Chamber of Commerce.)

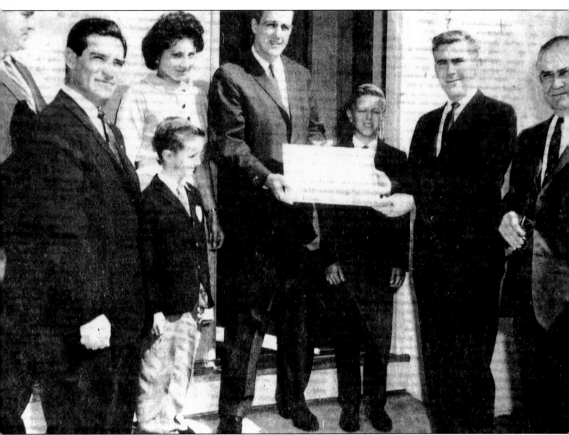

Charles Zerbe (center) is presented with a certificate by T. Jack Foster Jr. to commemorate the Zerbes as the first Foster City residents. Charles Zerbe (at the time a fireman with the San Francisco Fire Department) and his family moved into their home at 613 Pilgrim Drive on March 7, 1964. Pictured, from left to right, are Richard Foster, Bob Foster, Phyllis Zerbe, Philip Zerbe, Charles Zerbe, William Zerbe, T. Jack Jr., and T. Jack Sr. All Foster City pioneers had to contend with some inconveniences in the early years. Afternoon winds generated fierce sandstorms that stripped the paint off some cars, left sand drifts over a foot high in driveways, and deposited sand into houses underneath front doors; while ubiquitous jackrabbits munched on shrubs in front yards and made nighttime driving hazardous. Forty years later, the Zerbes are still living in the same house. (Courtesy of Charles Zerbe.)

Foster City Report

"The Island of Blue Lagoons"

VOLUME III, No. 1 FOSTER CITY, SAN MATEO COUNTY, CALIFORNIA SPRING - SUMMER, 1965

New Growth Record Set As Foster City Population Exceeds 1,500

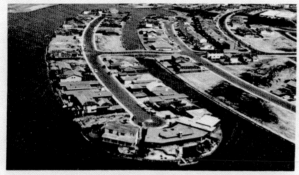

PROGRESS OF FOSTER CITY — Aerial view shows Flying Cloud Isle with custom homes in foreground and the first neighborhood in background. New school is seen in center of photo (white buildings). There are now 386 families residing in the new city and construction is underway in the second neighborhood. Population exceeds 1500.

FIRST FOSTER CITY SCHOOL — Almost 200 children of Foster City families are now enjoying school in their own classrooms immediately adjacent to their homes. Twelve classrooms and administration offices comprise structures on 7 acre site which was donated to school district by T. Jack Foster & Sons.

200 Children In New School

Builders Start Construction In Next Neighborhood

The growth of Foster City is moving ahead rapidly with the population now exceeding 1500 people, residing in 386 homes in the planned community which will, within a few years, be a complete city of 35,000 citizens.

Simultaneously, the first school in the new community has opened on a beautiful seven acre site at Polynesia and Niantic Drive with 200 children from kindergarten to the sixth grade in attendance. Delores Jackson, former assistant superintendent of the San Mateo Elementary School District is principal of the new school.

All of the completed homes in the first neighborhood are occupied and the three major builders — Duc & Elliot, Eichler Homes and Kay Homes have opened model homes in the second neighborhood. Many homes in the new area are already under construction.

A waiting list for homes still remains and all builders are working as rapidly as possible to fill the advance orders.

Builders believe they can, with the aid of good weather, accelerate construction and predict that by the end of this year, 1507 living units will be completed, indicating a population in excess of 5500 by that time.

The *Foster City Report*, pictured here from a mid-1965 edition, began on a grassroots level as a simple newsletter. The report was distributed to residents and contained news on the area's latest developments, updates on residential and commercial construction projects, and profiles of new families moving into the developing community. (Newsletter courtesy of Dean Hobbs.)

Foster City Report

"The Island of Blue Lagoons"

VOLUME IV, No. 2 FOSTER CITY, SAN MATEO COUNTY, CALIFORNIA FALL-WINTER, 1966-67

Growth Continues Despite Economic Conditions

Foster City Population Now Exceeds 5000 Residents

Industrial Park Moves Ahead

Motorola Headquarters Ready for Opening

The new $500,000 headquarters for Motorola Communications and Electronics, Inc., sales subsidiary of Motorola, Inc. is nearing completion and will be in full operation within the next few weeks it was announced today by T. Jack Foster, Jr., chief executive of Foster City.

The 20,000 square foot facility in the Foster City Industrial Park is

(Continued on page 2)

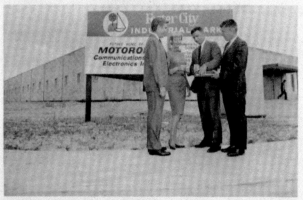

MOTOROLA BUILDING NEARS COMPLETION—Joseph Guido (second from right), executive with Motorola Communications and Electronics, Inc. demonstrates two-way radio communications device developed by Motorola. Others, left to right, are T. Jack Foster, Jr., chief executive officer of Foster City; Mrs. Gordon Penfold, wife of the Public Safety Chief of Foster City; Guido and H. Leland Troutman, manager for Foster City Industrial Park.

Population of Foster City exceeds 5,000 as this issue of the Foster City Report goes to press; more than 1,400 families are now residing here in homes, apartments and duplex facilities. This fine rate of growth is in spite of the "tight money market" which has been restricting the building industry all over the United States.

Home building continues strong in Foster City with 268 additional homes scheduled for immediate construction of which 127 are already underway. Among the major builders are Kay Homes, Eichler Homes, and Duc & Elliot.

Impressive as this record is in today's market, the rate of growth in the apartment rental field is also of important significance.

An occupancy of 60 per cent in the three apartment projects in Foster City was recorded only six months after opening. The Commodore, built by T. Jack Foster & Sons, with a total of 207 units; The Tradewind, built by Saxe & Yolles has 42 units and The Franciscan, built by Duc & Elliott has 125 units for a total of 374 units completed.

This trend has resulted in the decision of T. Jack Foster & Sons to add another unit to the Commodore, consisting of 72 one and two bedroom apartments for adults only; construction is scheduled to start soon.

This balanced growth reflects the excellent planning that went into Foster City five years ago. Before a single spade of earth was dug, plans were drawn which are now being translated into homes, apartments, shopping centers, offices and recreational facilities.

Another newsletter from late 1966 cites the reaching of the new population benchmark and the completion of the Motorola building on Chess Drive. (Newsletter courtesy of the Mooney family.)

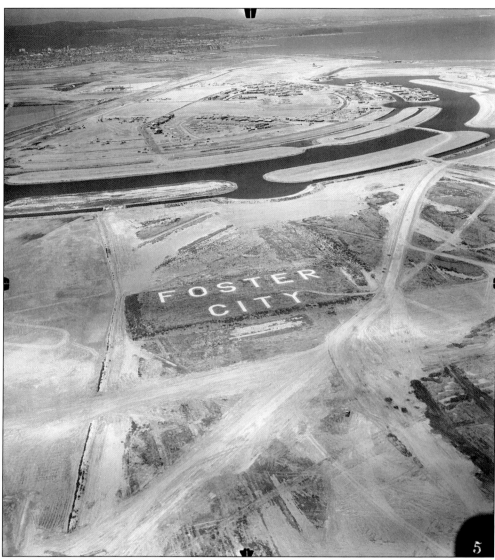

The original cement-lettered landmark is seen here c. 1964 in neighborhood three at the intersection of what is now Sea Horse Court and Swordfish Street. In the early days, T. Jack Foster Sr. traveled frequently and was known to request that flight crews, as they would descend toward SFO, inform their passengers to look out the window and see where Foster's new town was developing. This landmark, which read west to east, was nothing more than thin lettering built on topsoil. When the area was developed, the lettering was built over and redone at its present location on Beach Park Boulevard, across from Bowditch Middle School. It was made of a thicker cement and now reads from south to north. (Courtesy of City of Foster City.)

Erckenbrack Park opened to the public in May 1965 and was Foster City's first neighborhood park. This image, looking northeast from Niantic Drive, shows the old San Mateo Bridge in the background and the development of neighborhood two across the lagoon. (Courtesy of Foster City Chamber of Commerce.)

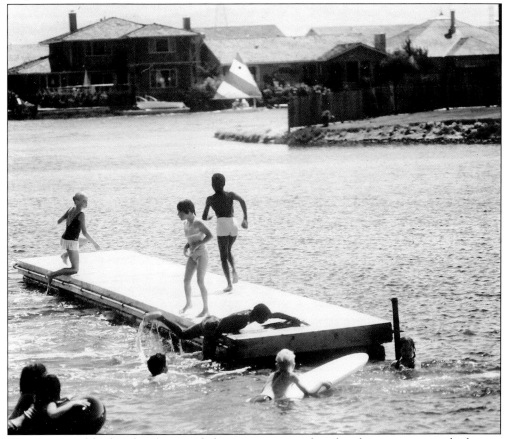

The city's neighborhood parks provided amusement on a hot day, for swimming in the lagoon or playing in the sand. This image from Gull Park shows children jostling about in the lagoon and on the float dock. From the 1960s to the early 1980s, each of the city's waterfront parks had a full-time lifeguard in the summer. (Courtesy of Lucy Williams.)

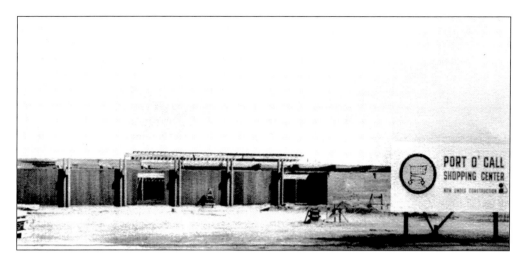

The first of Foster City's neighborhood shopping centers, Port O' Call, (pictured here under construction) opened in the fall of 1965 at a cost of $1,250,000 across the street from the Hillbarn Theatre on Hillsdale Boulevard. Entertainer Dennis Day (pictured below with the large scissors), who for years, starred on the Jack Benny Show, was on hand at the grand opening. The redwood building served Foster City residents' needs for grocery and other services in one enclosed area. It featured a 20,000-square-foot Safeway supermarket plus 10 other shops, including a Lock Drug Store, post office, beauty salon, barber shop, Arnold Palmer Cleaning and Pressing Service, electronics store, donut shop, liquor store, and a dockside restaurant. There was even a large bulletin board for residents to post announcements or for-sale items. Before Port O' Call, early residents had to shop in San Mateo. (Courtesy of Dean Hobbs and *San Mateo Times*.)

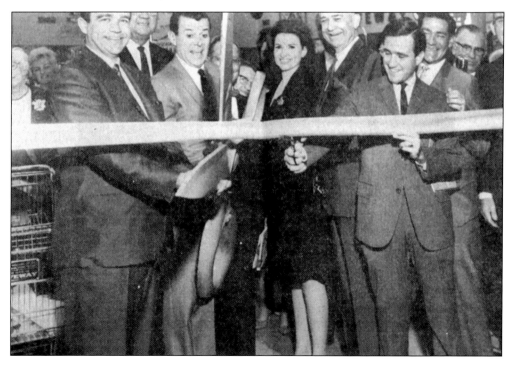

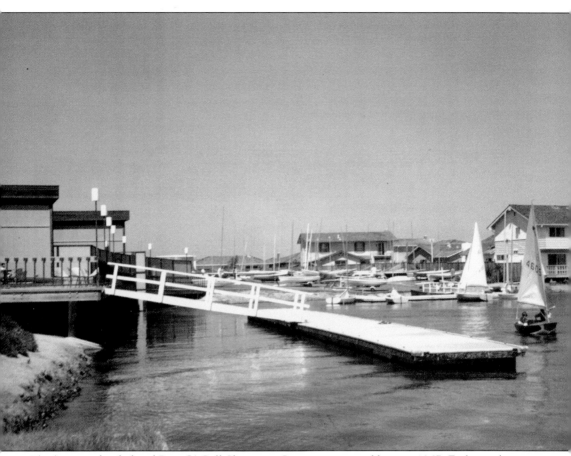

The boat garden behind Port O' Call Shopping Center is pictured here c. 1967. Early residents launched their sailboats from this site, adjacent to the dockside The Lobster Trap restaurant (later to become Senor Pepe's), which offered exceptional wide-water views. The 90-foot dock encouraged waterfront residents to "shop by sailboat." (Courtesy of the Foster City Chamber of Commerce.)

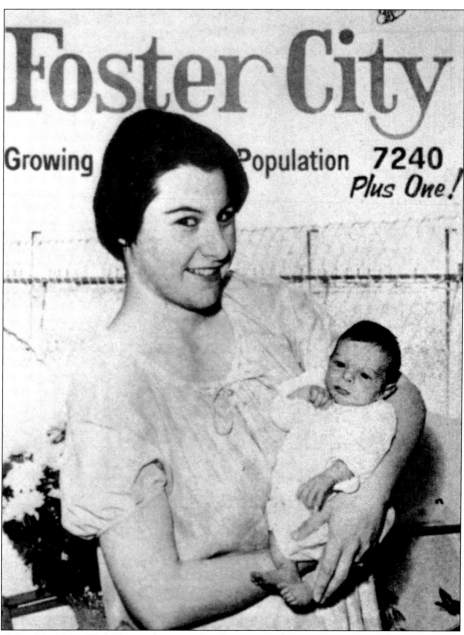

On May 24, 1968, Ted Shaine became the first native-born Foster City baby. Ted was born at the family home on Beach Park Boulevard and then rushed to Peninsula Hospital with his mother and father. Upon their return to the home a few days later, the Foster City billboard on Third Avenue, which listed the city's population growth, had recorded a large "plus one" along with a stork flying down from the upper right-hand side. The Fosters also sent the Shaines a gift in honor of the birth. Eileen Shaine and her husband, Larry, still reside in the same home in Foster City and continue to support the community. Both Larry and his wife are active on citizen advisory committees. As for Ted, he now resides in San Bruno and is system manager for Autotote, a division of Scientific Games Corporation based at Bay Meadows in San Mateo. (Courtesy of Eileen Shaine.)

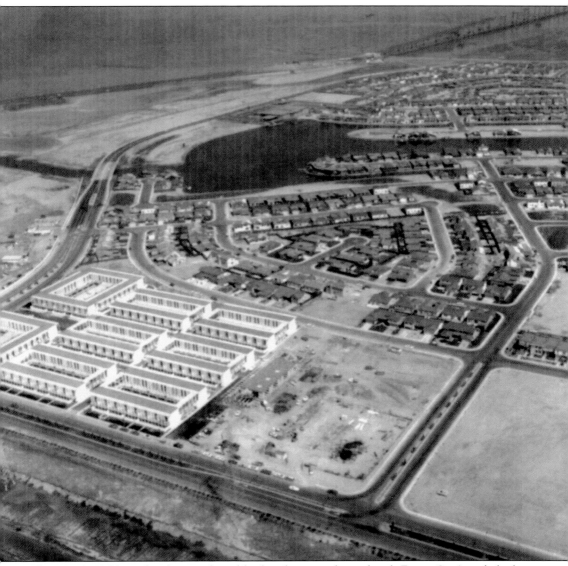

This March 1966 overhead view of neighborhoods one and two details Foster City's early look, which could best be described as "finished in some parts, but not even begun in others." In the foreground is construction on the Commodore Garden Apartments, now known as the Admiralty Condominiums. Architect Edward Durell Stone designed the complex, as well as the Foster and Wells Fargo buildings. At the top center is the new Port O' Call shopping center, and above that, to the right, is the construction of the new San Mateo Bridge alongside the original span. (Courtesy of Catherine Miskow.)

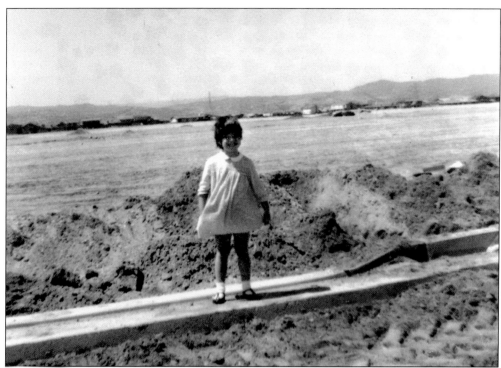

Five-year-old Dianne Damron stands in front of what would ultimately be her future home at 243 Loon Court, in neighborhood two, c. 1965. Scenes like this were common as many of Foster City's initial residents were new families with young children who had purchased homes before they had even been built. (Courtesy of Joanne Jacobs-Schwerin.)

This December 1964 photo shows the newly completed houses on Pilgrim Drive (including 673 Pilgrim in the foreground) looking northeast. The houses at 683 and 687 Matsonia are barely visible far left, behind the bicycling child. (Courtesy of the Foster City Chamber of Commerce.)

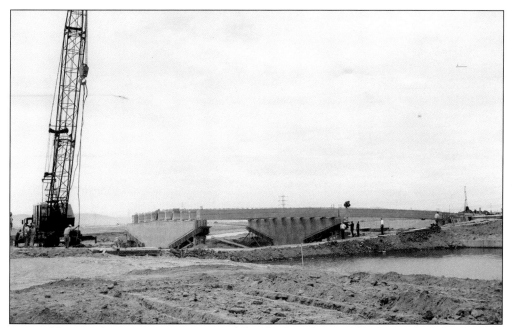

Pictured here under construction is one of four bridges that would ultimately link all of the neighborhoods in the city. The first bridge, dubbed the "Rainbow Bridge" opened in the spring of 1965 at a cost of $500,000 and linked neighborhood one with the Port O' Call Shopping center and neighborhood two. (Courtesy of Foster City Chamber of Commerce.)

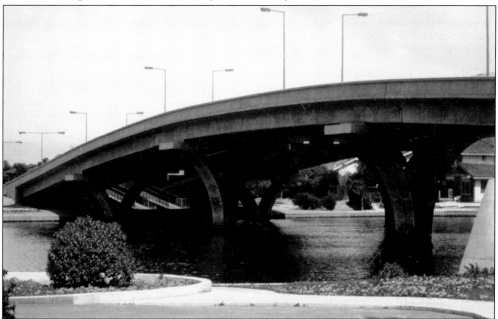

The Foster City Boulevard (shown here) and Shell Spans were designed by Wilsey & Ham and were completed in the fall of 1966; the last of four spans, appropriately named the Bicentennial Bridge, opened to traffic in 1976. The three neighborhood bridges, the exception being the Rainbow Bridge, were built high enough (22-feet clearance at the center) to allow sailboats to pass beneath. (Courtesy of the Foster City Chamber of Commerce.)

The construction site of the future Public Safety building is seen here c. 1965, across the street from the Foster Building on Hillsdale Boulevard (the current police and fire departments). Pictured at right in the top photo, next to an unidentified official, is Gordon Penfold, who, in July of 1965, became the city's first director of the newly created Department of Public Safety, which combined both police and fire services. Following incorporation in 1971, Penfold retired and was succeeded by John Norton, who headed the effort to split police and fire services into separate departmental functions. Robert Norman succeeded Norton following his retirement in 1981, and in so doing, became the city's first chief of police. In 2000, Randy Sonnenberg, a member of the Foster City Police Department since 1974, succeeded Norman. Sonnenberg retired in December 2004 and was replaced by Craig Courtin, the current chief of police. (Courtesy of the Foster City Chamber of Commerce.)

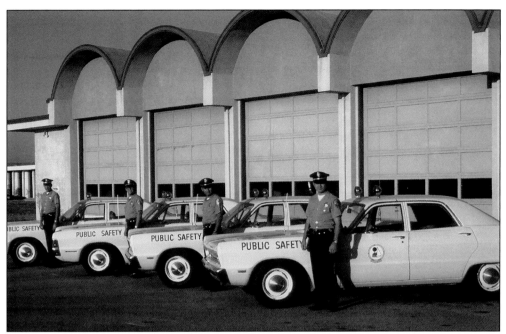

Public Safety Squad is seen here at the rear of the Public Safety Building in October of 1970. From left to right are Bob Halsing, Fred Ottinger, John Bettencourt, and Ron Stilwell. (Courtesy of the Mooney family.)

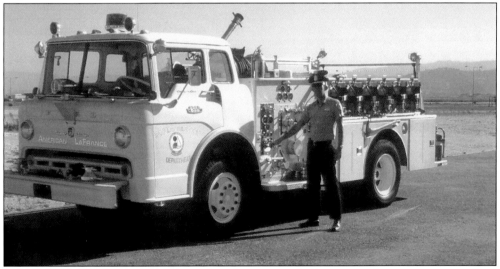

Prior to incorporation, the public safety department had just one fire engine in its fleet. Pictured here in October 1970 is public safety officer Bob Halsing beside that very engine. By the end of 1965, Penfold had hired 10 public safety officers. Today, the Foster City Police Department employs 40 sworn officers, while the fire department, headed by Chief Tom Reaves, consists of 37 full-time personnel, and is equipped with five vehicles (two engines, one spare, one truck, and one pump ladder). Previous heads of the fire department were as follows: William Tonguet, chief fire officer 1971–1977; John Bettencourt, chief fire officer/fire chief 1977–1993; Willie McDonald, fire chief 1993–1996; Philip Torre, fire chief 1996–2003. (Courtesy of the Mooney family.)

After the first neighborhoods had been developed, Foster City's marketing effort had a much different and "real" look. This brochure from 1969 gave would-be residents a glimpse of the unique lifestyle that the new city's pioneer residents had been enjoying over the past five years. (Brochure courtesy of Rich Bennion.)

This 1964 view at the corner of Pilgrim and Harvester Drives looking east, underscored T. Jack Foster Sr.'s philosophy of integrating a variety of home styles within the same neighborhood. At the left are Kay Homes models that attracted those wanting a ranch style home while the sign at the right directed buyers down Harvester Drive to the unique and imaginative design of the Eichler Home, modeled on Challenge Court. (Courtesy of the Foster City Chamber of Commerce.)

Pictured here in 1964 are Duc and Elliot model homes at the corner of Matsonia and Balclutha. Duc and Elliot, known for its traditional floor plans, joined Kay Homes and Eichler Homes as the city's original three builders. Prices for Foster City's first homes ranged from $21,950 to $40,000, with the larger custom-built waterfront properties fetching the highest prices in that range. Demand was brisk and several thousand families were placed on waiting lists. (Courtesy of the Foster City Chamber of Commerce.)

Pictured here are the City's first townhomes, at 701–711 Comet Drive near Balclutha. These six townhomes were the models of what was to be a larger development and were actually priced higher than some single family homes in the city. It was for this reason that the project ultimately failed, and the six townhomes stood alone without neighbors for over half a decade until the Treasure Island development was constructed on the lot in 1971. (Courtesy of the Foster City Chamber of Commerce.)

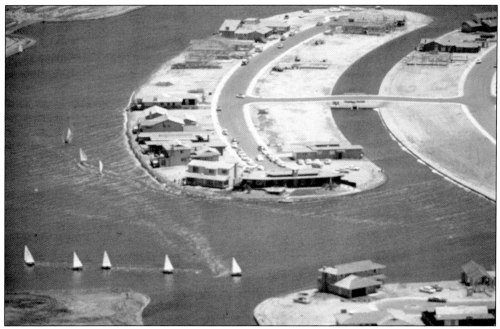

One of a dozen custom homes built by the Fosters, The Captain's House at 100 Flying Cloud Isle, is shown at the center of this photo. This property was so named as a promotional tag awarded to the city's first custom-built waterfront home. (Courtesy of the Foster City Chamber of Commerce.)

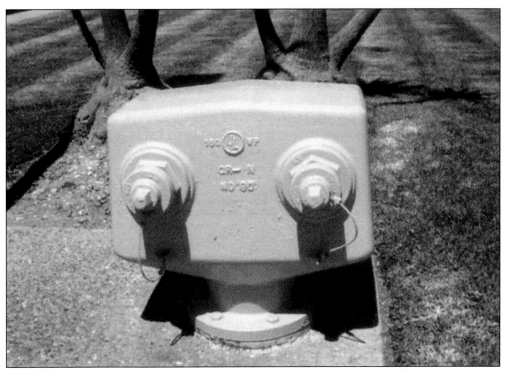

Development of Foster City progressed not only with a sense of diversity with respect to the neighborhoods and individual homes, but also with an eye for detail, notably when it came to the design of streets and utilities. Telephone and electrical power lines to residents and businesses were dug underground. The fire hydrants, which won a national design award, and the residential streetlights, both pictured here, were designed specifically for Foster City. The streetlights were composed of 30 aluminum fins set 10 degrees apart designed to softly focus sufficient light onto the streets and sidewalks below while at the same time limiting the amount of light intrusion into nearby homes. (Courtesy of Foster City Chamber of Commerce.)

Foster City *the island of blue lagoons*

T. JACK FOSTER & SONS • P.O. BOX 4100, FOSTER CITY, CALIF. 94404
1015 EAST HILLSDALE BLVD. • FOSTER CITY, CALIFORNIA 94404

Dear Foster City Newcomer:

It is my great pleasure to welcome you as a new resident of the great new community of Foster City. For your information, you will be a part of a community which is internationally known for the comprehensiveness of its planning. Several times a year Foster City is visited by groups interested in urban planning from all over the United States, as well as from other countries, particularly Japan and the West European nations.

More important, however, than the physical characteristics of Foster City are the people characteristics. There are now over 40 organizations which offer a wide variety of participation and which offer a means to relate to your fellow citizens and to your community. I sincerely hope that you will participate to the fullest and as a result of such participation and with all the amenities that Foster City and San Mateo County have to offer, you will consider your life here as one of great delight and you will think of Foster City as the best place you have ever lived.

Sincerely yours,

T. Jack Foster, Jr.

COURTESY OF WELCOME WAGON

This is a "Welcome Wagon" letter *c.* 1969 from T. Jack Foster Jr. which accompanied a welcome package given to new residents when they moved into Foster City. The package contained community maps and information relative to Foster City's neighborhoods, schools, parks, and shopping. (Letter courtesy of Lucy Williams.)

Dear Newcomer,

May we be one of the first, along with your neighbors, to welcome you to Foster City - a community I'm sure you'll find to be one of the nicest to be found anywhere.

On behalf of the Newcomers Club I would like to extend to you an invitation to join our club. Whatever your interests may be, I'm sure we have an activity group that should interest you. But more important, there is no nicer way to become acquainted with your neighbors, make friends, and generally make your life in Foster City more enjoyable.

We meet once a month, on the first Wednesday of each month, for luncheon at different restaurants in the area. You are cordially invited to join us, so we may become acquainted - who knows, you may encounter some previous neighbor. You are welcome to attend two luncheons before becoming a member. If within your first year here in Foster City, you should decide you would like to join our club, you may pay your dues of $6.00 for your two year membership.

Edna Athas or Carmel Scott, your welcoming hostesses, I'm sure will have answered most of your questions, however feel free to call me at any time if you should have any questions or if I may help you in any way. For weekly news concerning the activities of our club be sure to check your Foster City Progress.

We are looking forward to meeting you in the near future. Until then - WELCOME !

Sincerely,

Barbara Johnson

Barbara Johnson, President
379 Dolphin Isle
345-8639

Edna Athas, Sponsoring Hostess
845 Lurline Dr. - 349-1259

Pictured is a letter from the Foster City Newcomers Club. Formed in April 1966 by 36 women led by Edna Athas, the sponsoring hostess, it was designed to plan community activities and give neighbors the opportunity to get acquainted with one another. The club was so popular that by the end of the year, membership had increased nearly tenfold. (Letter courtesy of Lucy Williams.)

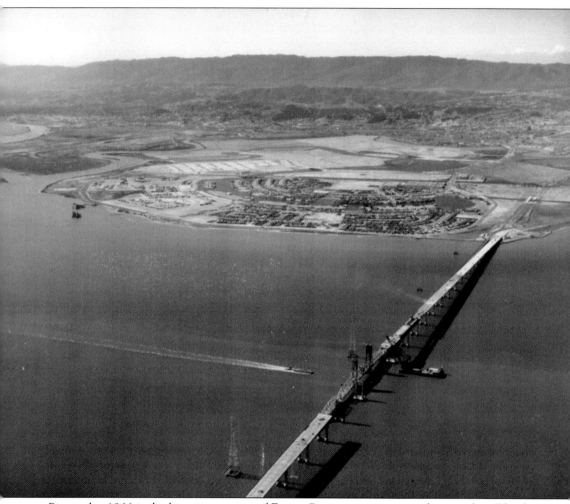

Pictured c. 1966 is the big-picture view of Foster City progressing according to plan. The first three neighborhoods are shown almost completely finished, with neighborhood four's streets paved and construction to shortly commence. Note that the new San Mateo–Hayward Bridge is nearing completion, ultimately opening to traffic on October 20, 1967. The old "lift" span continued to serve during the current span's construction. (Courtesy of the City of Foster City.)

Four

EARLY CIVIC LEADERS

There is enough information about Foster City politics in the 1970s to fill a dissertation and to discuss the topic in depth would be beyond the scope of this book. However, in order to properly understand Foster City history, it is necessary to have a general background knowledge of the politicking that led to the incorporation and development of the city as we know it.

The story of Foster City's governmental structure has its roots in T. Jack Foster Sr.'s methods of financing his project. Few banks, if any, were willing to back such an ambitious project, then Foster came across a little-known method called the Special Improvement District method, wherein a governing board would be created for the purpose of overseeing the improvement of a specific parcel or parcels of land within an existing city. Foster asked the California state assembly to introduce a bill to create the "Estero Municipal Improvement District;" the bill was signed into law in 1960. Under the terms of the Estero Act (SB 51) the district would be governed by a three-member board of directors, which had the power to sell municipal bonds to finance the building of the city. Once the project was completed, and the need for the Estero Board theoretically eliminated, residents would be given three options: retain the Estero Board as a form of government, annex to the City of San Mateo or incorporate as a separate city.

The Estero Board functioned as the ideal form of government for the fledgling city, but by the mid 1960s, residents began to demand more input in local affairs. Future mayor Wayne McFadden and another prominent citizen, Dr. Charles Monahan, founded the Foster City Community Association (FCCA) in 1964, the goal of which was to address citizen concerns not directly ruled by the Estero board. McFadden particularly disliked the board's methods of selling new bonds to pay off interest on existing ones and argued that based on the property taxes paid by the residents, members of the FCCA should have a voice in how the money would be spent. Two years later, McFadden approached T. Jack Foster Sr. to ask about citizen representation on the

Estero Board; Foster agreed that any such membership would be ad hoc and the citizens would have no voting power, essentially resulting in a form of "taxation without representation." Outraged, McFadden went to the state assembly and asked them to reexamine the original SB 51 act that chartered the board. In a final compromise, it was decided that two residents would sit on the Estero Board, and in November of 1969, a third resident member would be elected. McFadden and Monohan were chosen to fill the two resident slots and in 1969, Alvin Potter was appointed to fill the third spot.

By the beginning of 1970, the board began to explore the three options outlining the future of the city. San Mateo rejected the annexation proposal on the basis that it did not wish to assume the Estero bond debt; the proposal to incorporate was sent to the residents in a petition and returned with 74 percent of residents signing in favor. In the election, 78 percent approved. Incorporation day was set for April 27, 1971.

The new form of government was to be a city council with five members. Of the 12 candidates, Wayne McFadden was garnered the most votes and was named the mayor of the new city. Over the course of the next 10 years, the city would encounter political rough seas including going through seven city managers in 1977 alone. After that turbulent year, Foster City's government stabilized and the city has had only two city managers since 1978. In fact, one of Foster City's most outstanding mayors during the 1980s, Roger Chinn, pointed out the fact that many of the political leaders in the late 1970s and early 1980s in a sense "grew up" together, learning their craft by serving at an earlier time in the city's Lions or Rotary Clubs, and this early seasoning provided the later consistent, strong city leadership when it was most needed. The last of the Estero bonds is expected to be paid off in 2007, finally laying to rest a particularly tempestuous political hot potato in Foster City's history.

Pictured here is Foster City's first mayor, Wayne McFadden. He now runs a law practice in San Mateo. (Courtesy of Wayne McFadden.)

The Estero Board essentially managed the city from 1960 up until the 1971 incorporation. In fact, George Shannon (pictured far left) was a district manager until 1969. (Courtesy of the Foster City Chamber of Commerce.)

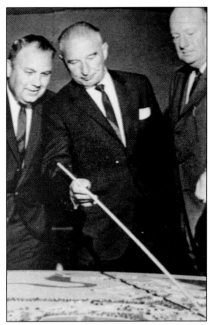

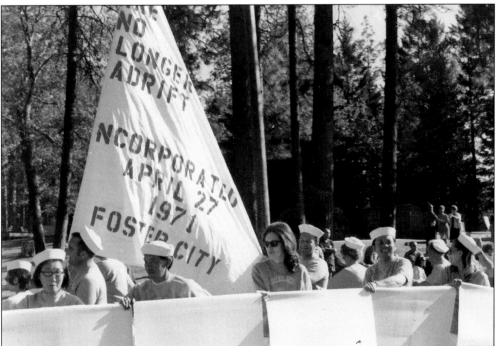

On April 27, 1971, Foster City was officially incorporated as the newest city in San Mateo County. Its incorporation marked the end of a long and contentious battle between inchoate City Council, the Estero Municipal Board, San Mateo County, and Foster City's residents. The occasion was formally celebrated a week later with speeches, parades, and a non-denominational religious invocation. This celebration was repeated annually at "Foster City's Birthday Party," although it never approached the grandeur of the original ceremony. (Courtesy of the Mooney family.)

Pictured above celebrating Foster City's incorporation at Central Park in May 1971 are, from left to right, (front row) two unidentified children; (back row) James Smith, James Duffelmeyer, Wayne McFadden, Mark Reeve, and William E. Walker. The recreation center on Shell Boulevard now bears Walker's name. (Courtesy of Nevin Duerr/San Mateo County Historical Association.)

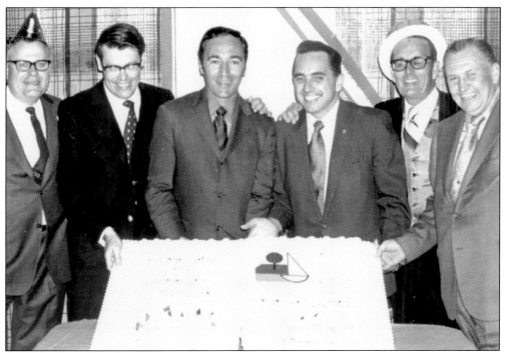

Pictured, from left to right, are Ed Keyser, Wayne McFadden, Ralph Lomele, Mark Reeve, James Dufflemeyer, and William Walker celebrating the incorporation of Foster City. (Courtesy of Ralph Lomele.)

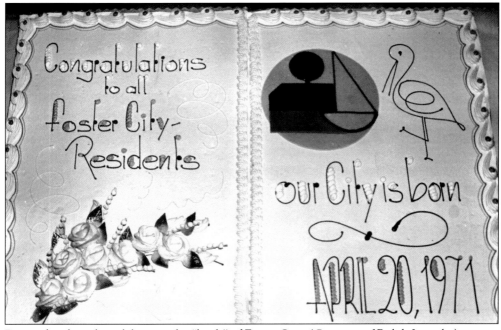

Pictured is the cake celebrating the "birth" of Foster City. (Courtesy of Ralph Lomele.)

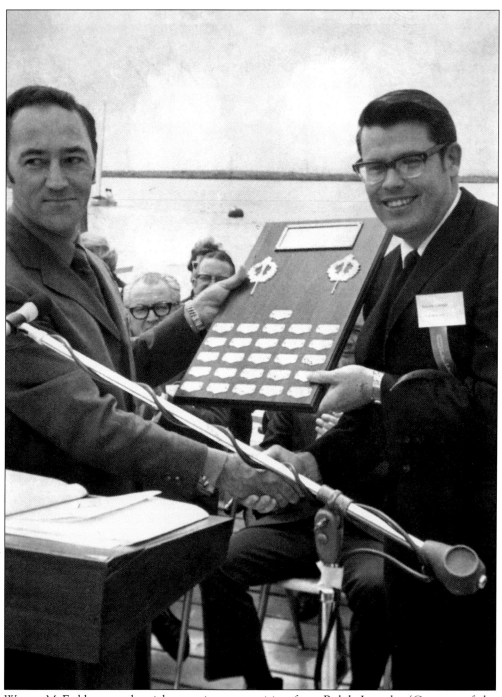

Wayne McFadden, on the right, receives recognition from Ralph Lomele. (Courtesy of the Mooney family.)

Secretary of State Jerry Brown (seated) and Assemblyman Leo Ryan (standing far right) are pictured here with the first city council. Pictured, from left to right, are Mark Reeve, James Duffelmeyer, Mayor Wayne McFadden, Ed Keyser, and William Walker. (Courtesy of Foster City Chamber of Commerce.)

This 1970 *Foster City Progress* article highlighted the October 21 decision of the Local Agency Formation Committee (LAFCO) to allow the unincorporated community to become San Mateo County's 19th city. This was one of the instrumental decisions that would lead to the incorporation just six months later in 1971. (Courtesy of *Foster City Progress*.)

LAFCO Hearing
Foster City Wins Incorporation

Foster City won its chance for cityhood October 21 as Local Agency Formation Commission in a surprise decision voted unanimously to allow the unincorporated community to become San Mateo County's 19th city.

Unexpected action came at the end of a day-long hearing, without a single opponent putting in an appearance.

Board of Supervisors must now set a special election to allow residents of Foster City to vote on incorporation, LAFC Executive Officer Sherman Coffman said. This may coincide with school elections set for April, 1971.

Centex-West, Dallas, Texas last week acquired 1500 acres of Foster City including the balance of undeveloped lands from the Foster California Corporation.

"We would like to go on record in support of incorporation, not only for the municipal revenue that will be forthcoming, but to add to the pride of the people of Foster City," Jerry Crossen of Centex-West told the Commission. His statements were echoed by representatives of Boise-Cascade and L.B. Nelson Corporation of Palo Alto.

As majority landowner, Centex now controls incorporation, Commission Emory Morris pointed out.

What emerged clearly during the presentation by members of the Estero Municipal Improvement district was the political impossibility of Foster City annexation to the City of San Mateo, the alternative to incorporation.

Estero Director Wayne McFadden testified that at a meeting on October 15 with four members of the San Mateo city council, each member stated flatly that he would be opposed to assumption of Foster City's $85½ million bonded indebtedness.

"They don't want our bonds, they want our assets, they want our financial base, our commercial base," McFadden said, referring to a new sphere of influence request filed by San Mateo which takes in 126 acres of Foster City industrial lands west of 3rd Avenue and most of the shoreline and submerged lands owned by West Bay Associates.

McFadden argued that if San Mateo were to annex Foster City it would simply be substituting city government for county government, and would not affect the Estero bond service district.

In drawing the final boundary lines, LAFC commissioners left Foster City intact and revised line in the Bay to include the San Mateo-Hayward bridge.

In an accompanying action, the Commission also approved formation of subsidiary bond service district. If incorporation and formation of the subsidiary district are approved by the electorate, existing Estero Board members will go out of office and the newly-elected city council members will become the governing board

BETSY SCHLIPP AND FOSTER CITY FRIENDS — Invite you to St. Matthew Book Fair and Raffle Oct. 28-30 at Julia Beylard Hall, Baldwin and El Camino San Mateo. Miss Schlipp, the school's librarian and former children's librarian at the San Mateo Public Library, will help people in their selection of books and will entertain young visitors with stories. Friends are (l-r, seated) Steve Welch, Valerie Welch

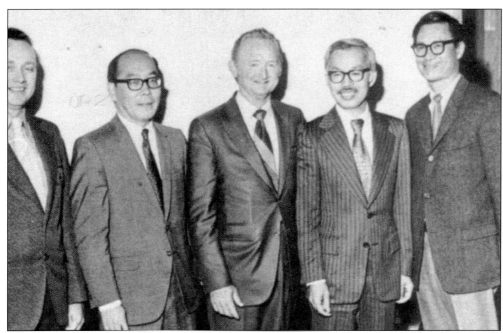

The members of the first Foster City planning commission were, from left to right, Lee Dozier, Kiyoshi Matsuo, Paul Nelson, Bob Hong, and Roger Chinn. (Courtesy of the Foster City Chamber of Commerce.)

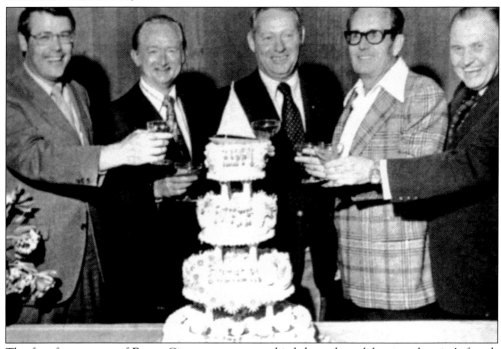

The first five mayors of Foster City pose next to a birthday cake celebrating the city's fourth birthday in 1975. Pictured, from left to right, are Wayne McFadden (1971), Paul Nelson (1973), John Lappin (1975), James Duffelmeyer (1974), and William Walker (1972). (Courtesy of the Foster City Chamber of Commerce.)

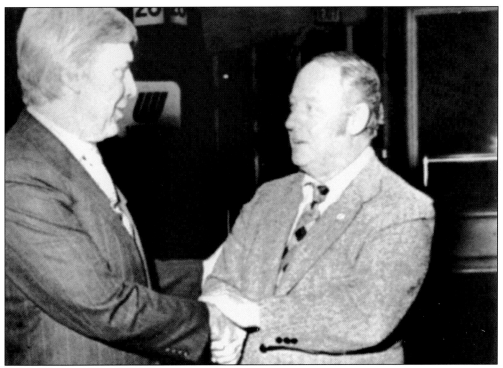

Congressman Leo Ryan (left) and Mayor John Lappin celebrate the acquisition of the landfill permit in February of 1976. Acquisition of the permit meant that the city could continue its growth and expansion. (Courtesy of the Foster City Chamber of Commerce.)

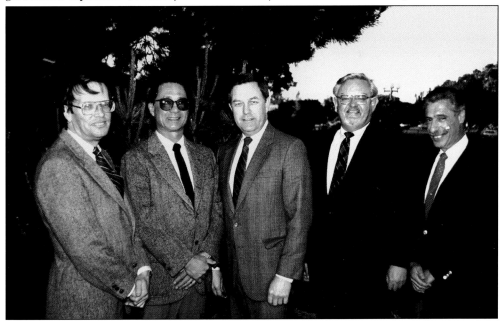

Pictured here in November 1987 are, from left to right, Councilman John Oliver, Councilman Roger Chinn, Mayor Bob Fitzgerald, Councilman Riho Martinson, and Vice Mayor Tom Battaglia. (Courtesy of the Foster City Chamber of Commerce.)

On November 27, 1978, Congressman Leo Ryan was assassinated in Jonestown. Wanting to recognize Ryan's support for incorporating Foster City, Central Park was renamed Leo Ryan Memorial Park in 1979. (Courtesy of Catherine Miskow.)

Five

EDUCATION

When the first pioneer residents arrived in Foster City in the early 1960s, the city had no educational facilities within its boundaries. The nearest elementary school was either Lakeshore Elementary or Fiesta Gardens, both located in neighboring San Mateo; junior high school students had a choice of either Abbott or Bayside Middle Schools and high school students attended either Hillsdale or San Mateo High Schools. Foster's original master plan called for nine elementary schools, one in each neighborhood, two middle schools and a central high school, but it would be almost a year before any educational facilities would be built in Foster City.

The city's first official elementary school, duly named Foster City School, opened in 1965 on Polynesia Drive in neighborhood one. Intended to be a temporary structure, the school consisted of 23 portable classrooms, a central, multipurpose room, and two separate playgrounds, one for upper grade and one for the lower grade students. It remained the city's only elementary school until the opening of Audobon Elementary in 1968. Audobon's opening relieved some of the congestion at Foster City School and allowed children living in neighborhoods two and three to attend school closer to home.

Bowditch Middle School, opened in 1969, remains the city's only upper elementary level school. The campus featured an innovative "pod" style design, wherein a teacher could open a folding partition and co-teach across the curriculum with a teacher in a neighboring classroom. Students who attended Foster City's two elementary schools usually attended Bowditch for middle school.

By 1980, the "temporary" elementary school had been in place for 15 years with no plans on the board to replace it. Not only were the portables badly outdated, the school had also far exceeded its capacity, combining grade levels in an effort to conserve space. In 1982, plans were made for the building of a new, permanent elementary school, located on the opposite side of the city. Groundbreaking was held in the fall of 1984 and Foster City Elementary West Campus, popularly known as the "new school," was partially opened to grades kindergarten

through third in 1985, while fourth and fifth graders were allowed to continue attending the old "East Campus." Families living in neighborhoods one, two and three were given the option of sending their children to Audobon. One legacy of the old school zoning remained, though—some children living in Foster City still attended elementary or middle school in San Mateo. At the end of the 1984 school year, San Mateo's Lakeshore Elementary was closed, followed in 1985 by Fiesta Gardens. The remaining students were transferred into Foster City schools. The temporary campus was permanently closed in 1986, the remaining students transferred to either Audobon or the "New School."

Following the site's closure, the Parks and Recreation department and the San Mateo Union High School District's Adult School ESL classes used the buildings alternately. In 1994, the site was razed to make room for a third elementary. Brewer Island Elementary School opened in 1995, relieving congestion at the now overcrowded "new" Foster City School.

Since 1986, three new schools, including Brewer Island Elementary, have opened in Foster City, most recently Kids Connection, a K–5 private elementary school, and the Ronald C. Wornick Jewish Day School, a private K–8 school. One thing that was never completed though was the proposed high school. Early maps and promotional brochures show the site of the "Future Marina High School," but political, economic, and other building developments have stymied the effort to construct a secondary school in Foster City. A consortium of citizens recently attempted to revive the idea of a city high school in 1996, unfortunately, the proposal has been frequently defeated due to lack of funds, lack of interest, and lack of space. It is somewhat ironic that students must once again return to San Mateo for school despite living in the now fully incorporated Foster City. Currently, however, there is an effort by some citizens to construct a smaller charter high school on a portion of the original high school site.

During Bowditch Middle School's first academic year of 1969–1970, the school organized a yearbook cover-design contest, and all students were invited to participate. The winning entry, pictured here, was submitted by Jo Ellen Chew, an eighth-grader. Prior to Bowditch's completion, middle-school students were bussed to schools in San Mateo. Once Bowditch opened, Foster City's pre-high-school student population was happy to finally be attending a school that they could call their own. (Courtesy of Ed Schuler and Bowditch Middle School.)

Pictured here are the main office and front of the Old Foster City School, located at 1151 Poly-nesia Drive. The hastily erected campus opened in 1965 and consisted of 23 portable classrooms and a main assembly (LGI, or large group instruction) room, and served as the city's only elementary school until the opening of Audubon school in 1968. The campus was intended to be temporary, but remained open until its closure in 1986. The buildings were torn down in 1992 to make room for the new Brewer Island Elementary School. (Courtesy of Catherine Miskow.)

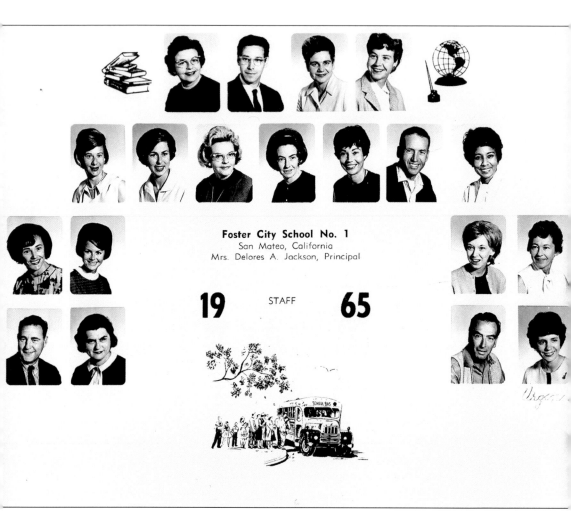

Foster City School No. 1
San Mateo, California
Mrs. Delores A. Jackson, Principal

19 STAFF **65**

This is the Foster City School's first annual faculty and staff photograph from the 1965–1966 school year. From left to right are (first row) Tom Mahoney, Elizabeth Johnson, Mr. Lusvardi, and Virginia Bennett; (second row) Anne Fuller, Diane Murphy, Joanne Harsh, and Jean Bailey; (third row) Carol Wilson, Carol Gammeter, Mary Creehan, Betsy Vandenberg, Debbie Deutermann, Ray Traynor, and Evelyn Taylor; (fourth row) principal Delores Jackson, Steven Kopel, Jean Wilson, and Ruth Fredericks. (Courtesy Anne Fuller.)

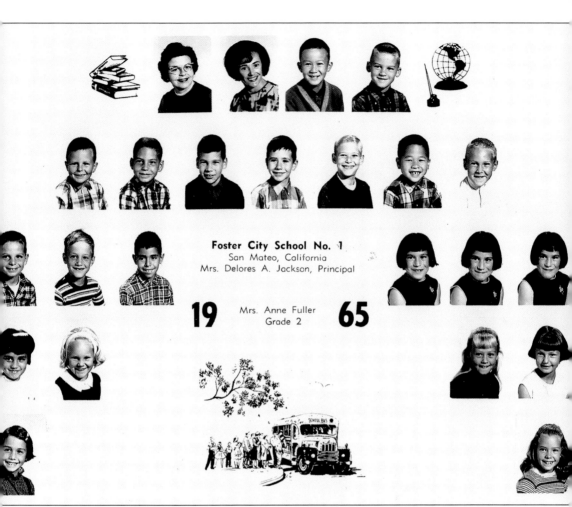

Foster City School No. 1
San Mateo, California
Mrs. Delores A. Jackson, Principal

19 Mrs. Anne Fuller **65**
Grade 2

Seen here is Anne Fuller's 1965 second-grade class at Foster City Elementary School. The opening of Foster City School allowed the students to attend classes in their own community without having to be bussed out to San Mateo schools. (Courtesy of Anne Fuller.)

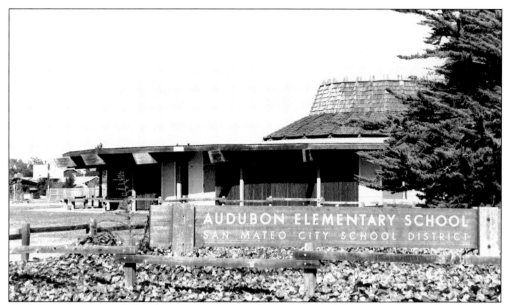

Audubon Elementary School opened in 1968, relieving some of the congestion at the old Foster City School. In 1997, Audubon was named a California Distinguished School, and received a new multipurpose building the following year. The campus recently underwent renovation, although its current appearance is relatively unchanged from when it originally opened. (Courtesy of Diane Daniels.)

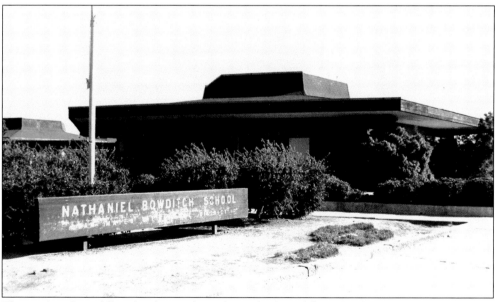

The city's only middle school is Nathaniel Bowditch Middle School, which opened in 1969. Most students who attend the city's three elementary schools continue on at Bowditch. The school featured a unique "pod" arrangement wherein a teacher could open a partition to the neighboring classroom and engage in a lively "co-teaching" program across multiple subjects. (Courtesy of Diane Daniels.)

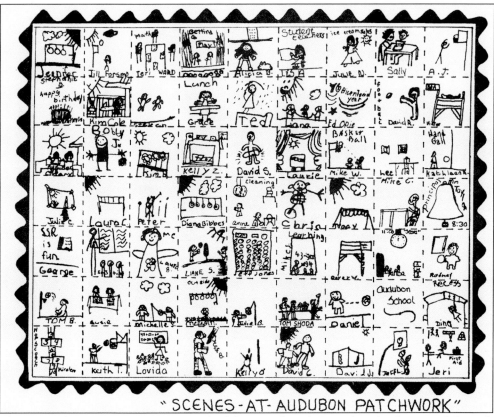

"SCENES-AT-AUDUBON PATCHWORK"

This original composition, "Scenes-At-Audubon Patchwork," was done by the second through fifth grades of Audubon School, c. 1976. (Courtesy of Lucy Williams.)

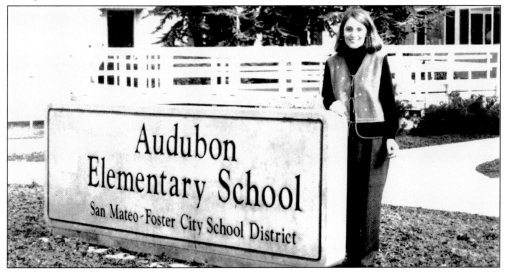

Fran LeMoyne served as principal of Foster City's second elementary school from 1993 to 2001. She is pictured here in front of the main school sign. The new Audubon multipurpose room was dedicated to her after her death in 2002. Note the new sign in front of the campus now reads "San Mateo–Foster City" School District. (Courtesy of Audubon Elementary School.)

73

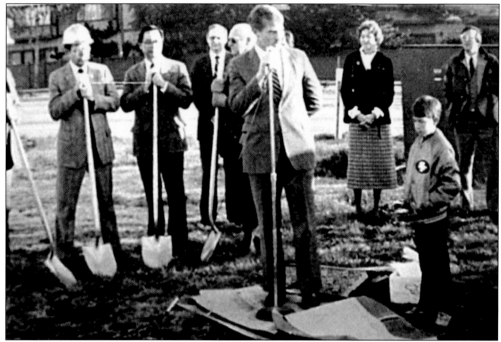

Foster City School Student Body President David Gilbert (in 49ers jacket) presides over the groundbreaking for the new Edgewater campus. Pictured beside him are the superintendent of schools, Dr. Julian Crocker (center), members of city council, and the contractors for the building. (Courtesy of Catherine Miskow.)

By 1983, it became evident that Foster City School had outgrown its temporary facility, and a permanent facility was necessary. The new campus, shown here prior to construction, is located on the corner of Edgewater and Beach Park Boulevards, and has a capacity of 1,000 students in permanent classrooms rather than portables. When the new school opened in the fall of 1984, kindergarten through third graders attended the new campus, while fourth and fifth graders remained at the old campus. In the fall of 1986, all grades officially moved into the new campus. (Courtesy of Catherine Miskow.)

Brewer Island School is seen here under construction in 1995, on the same grounds where the original Foster City School once stood. Brewer Island School became Foster City's only year-round campus. (Courtesy of Nevin Duerr.)

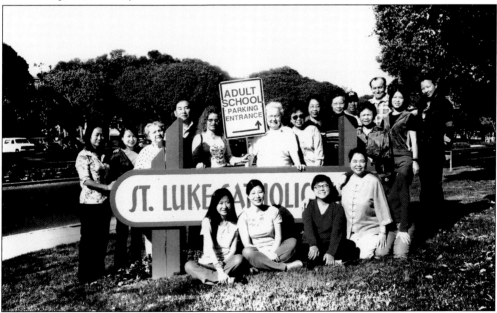

San Mateo Union High School District's adult school classes of English as a second language were started in Foster City in 1974 with the help of the Foster City Parks and Recreation Department. Marcia Cohn-Lyle began with 15 students housed in the Recreation Center's Bar Lounge. Classes expanded to Temple Peninsula Sinai, recombining at the old Foster City School site on Polynesia. Following the demolition of the old Foster City school site, the classes were relocated to the site of Saint Luke's Catholic Church. (Courtesy of Marcia Cohn-Lyle.)

Founded in 1988 by Linda Koelling, Kids Connection began by offering preschool only, and then added kindergarten in 1989. The acquisition of an adjacent building in 1994 resulted in the creation of Foster City's first private elementary school. Plans currently exist to expand the school to a kindergarten through eighth-grade facility. Linda Koelling currently serves as the newest member of the Foster City Council. (Courtesy of the Foster City Chamber of Commerce.)

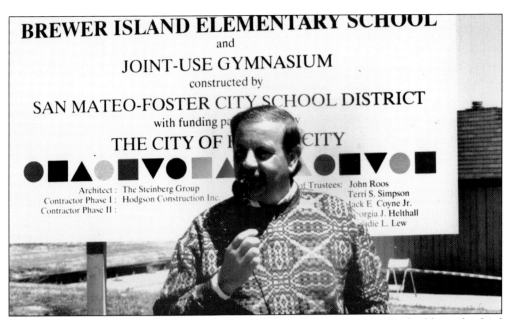

By 1992, Foster City's population had burgeoned enough to necessitate the building of a third elementary school campus. Pictured is District Superintendent Rick D'Amelio at the site of Brewer Island Elementary School in 1995. (Courtesy of Larry Staley.)

Seen here is one of the first kindergarten classes to attend Brewer Island Elementary School in 1995. (Courtesy of Diane Daniels.)

In 1998, a site was secured in Foster City to house the Jewish Day School of the Peninsula and the Peninsula Jewish Community Center. The grand opening of this kindergarten through eighth-grade private school was held on February 9, 2004 and the school was renamed the Ronald C. Wornick Jewish Day School. (Courtesy of the Ronald Wornick Jewish Day School.)

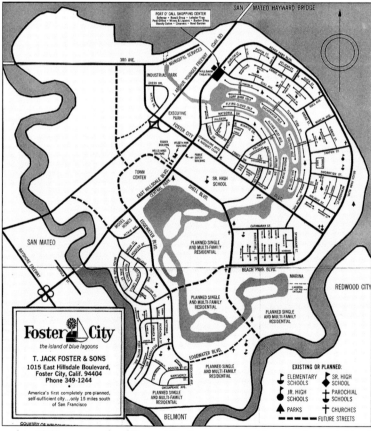

As shown on this 1969 map, each of Foster City's current and future nine neighborhoods would feature a school. The idea to construct a secondary school in Foster City has been mentioned as recently as 1996, but has been voted down due to insufficient land allocation. Students living in Foster City attend high school in neighboring San Mateo. As of late 2004, a small consortium of citizens is trying to bring a charter high school to the city, possibly as early as August 2005. (Courtesy of Lucy Williams.)

Six

RECREATION AND LEISURE

The original plan for parks and recreation anticipated that active recreation would be on the school sites. The more passive recreation would be in Foster City's neighborhood parks adjacent to the schools and in Central Park. When the school district backed away from the earlier decision that they wanted nine elementary school sites, the need for places for active recreation then fell to Foster City.

Credit for expanding the original park plan to solve the active recreation needs goes largely to William Walker, the second mayor of Foster City and a member of the Park and Recreation Committee. Walker and other members of the Foster City Community Association successfully lobbied to expand Central Park and to create Sea Cloud Park, probably the most successful active recreational park in San Mateo County.

Central Park was rechristened "Leo Ryan Park" in 1979 to honor the congressman who had lobbied so hard to recognize and incorporate Foster City. Walker also crusaded actively for the establishment of a recreation center, although several residents criticized him for wanting to obtain a liquor license for the center.

The central lagoon is, of course, the defining feature of Foster City's recreation. On a sunny weekend day, any number of watercraft—from inflatable dinghies to kayaks to electric boats can be seen cruising the city's 16 miles of navigable lagoons. Even the bridges, with their 22-foot clearance, providing space for even the highest sailboat masts, were designed to go with the city's boating obsession. This love for the water resulted in a number of boating oriented organizations such as the Island Sailing Club, headed by Jim Moore. The club sponsored regattas, races, and sailing classes, and in the summer and spring, colorful sails of Sunfish boats and catamarans could be seen dotting the lagoons. Most of the city's waterfront parks had beaches and docks and on a hot summer day, Foster City looked more like a Southern California beach town, with colorful sun umbrellas and beach towels dotting the park scape. Every waterfront park also had a full time lifeguard keeping watch over the swimmers and making sure that the boaters did not overrun the swimmers.

In addition to the water sports, land-based youth sports have played an active role in Foster City's recreational fabric since the beginning, and several athletes who got their start in the dirt fields of Foster City have gone on to professional prominence. AYSO soccer, Little League Baseball and Softball, and Pop Warner Football afforded Foster City youths the opportunity of participating in a variety of competitive, organized sports. Although Little League and youth soccer are still active in the community, the Foster City Youth Football League was dissolved in the 1980s, its role now filled by the Peninsula chapter of Pop Warner Football. The Island Sailing Club, so popular during the 1970s and early 1980s, disbanded due to lack of interest as water-sport aficionados opted more for kayaking or motor boating than sailing.

In 1998, the city honored Walker for his efforts in fostering the city's recreation program,

christening the newly renovated recreation center the William F. Walker Recreation Center. The new center boasts amenities for all ages, including a senior citizen's wing, a youth and teen wing, and an expanded preschool/daycare facility. Walker passed away in 1999, but his legacy in Foster City recreation lives on.

The Foster City Little League Auxiliary was comprised of women who were mothers or guardians of players, wives of coaches, relatives, or friends. These auxiliary groups were the backbone and workhorses of support to each sport. Pictured, from left to right, are (front row) Margaret Dale, Nancy DeHoff, Nancy Manlowe, Nancy Sopp, and Melanie Stewman; (middle row) Mary Ann Lee, Loretta Greco, Ina McClenaham, Jean Delmonico, Evelyn Ohira, and Mrs. Miranda; (back row) Maureen Bonamo, Trudy Moore, Lucy Williams, Barbara Jones, and Louise Parmett. (Courtesy of Lucy Williams.)

Pictured are the 1996 Foster City Division AAA Giants who finished with 10 wins and seven losses and beat the A's in a playoff game before losing the next one to the Braves, the eventual champions. Pictured, from left to right, are (front row) Tyler Borzello, Aaron Staley, Jonathan Michael, P.J. Holper, Bobby Amirkhan, and Bryan Epp; (middle row) Johnathan Coppedge, Adam Carrow, Chris Merrick, Matthew Culores, Ryan Twomey, and Frosty Spiegel; (back row) head coach Joe Borzello, assistant coach Jeff Epp, assistant coach Mitch Carrow. (Courtesy of Larry Staley.)

Youth sports are a large part of a community's fabric, and Foster City is no exception. AYSO soccer, Little League Baseball and Softball, and Pop Warner Football afford Foster City youths the opportunity to participate in a variety of competitive, organized sports. Little League programs such as this one from 1976 publicized team rosters, schedules, and sponsors. The Lions Club and several business organizations have long been generous with their support of Foster City Little League, which in 2004 fielded over 40 baseball teams and a dozen softball teams. (Courtesy of Lucy Williams.)

A popular sport with Foster City youths, AYSO soccer continues to flourish as the city's largest sport activity with over 125 teams made up of over 1,300 kids, affording boys and girls between the ages of 4 and 18 years old the opportunity to enjoy the sport of soccer. (Courtesy of Foster City Chamber of Commerce.)

The Lions Club sponsored a Girls Softball league, which, in the early years, played its games in the fields adjacent to the old Foster City School on Polynesia Drive. This image dates from the late 1960s. (Courtesy of the Mooney family.)

Early adult softball leagues were played in the late 1960s on this Shell Boulevard site, which is now home to the current recreation center. (Courtesy of the Mooney family.)

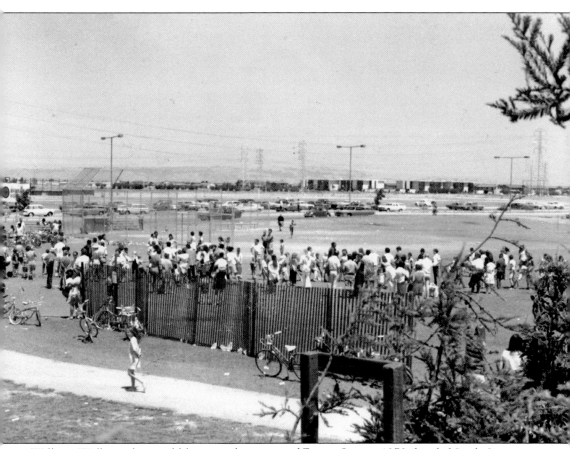

William Walker, who would become the mayor of Foster City in 1972, headed Little League Baseball, the first sports organization in Foster City. Boys Little League was played on the plot of land south of the Police and Fire Departments between Shell and Foster City Boulevards (in the far background of this late 1960s view from Central Park). Wind and dust were a constant annoyance, and fields consisted of makeshift diamonds that were a far cry from the nicely manicured grass baseball fields found today at Sea Cloud Park. A Sports Wall of Fame was recently erected at Sea Cloud Park and acts as a dedication to the early contributors who throughout the City's history were committed to Foster City's Youth Athletics. The people listed on the wall are Jeff Brown, John Cline, Paul Delmonico, Manny Hirschel, Peter Klein, Tom Munro, Steve Okamoto, Mickey Orloff, Lew and Louise Parmett, Greg Patrick, Pete Pershing, Jim Pounds, Jorge J. Rodriguez, and Aki Watanabe. Carl Smith was very active with youth baseball, having served as one of the first coaches of Foster City Little League and was responsible for setting up the town's first baseball batting cage.(Courtesy of the Mooney family.)

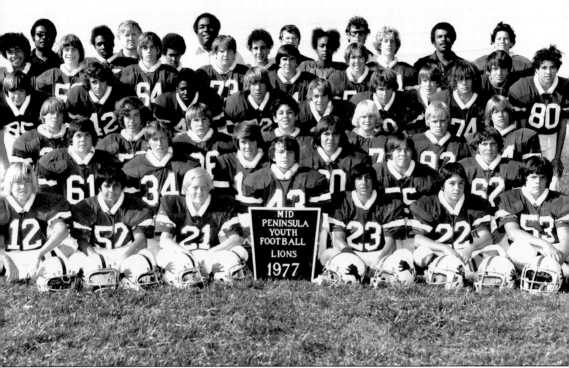

The Mid Peninsula Youth Football League was formed in 1969 and featured the Lions Club–sponsored Foster City team—the Lions—along with squads from San Mateo, Burlingame, and Hillsborough. Redwood City, Daly City, and Belmont later joined the league. In the mid-1970s, as Foster City's population grew and its interest in local youth football expanded, three new Foster City teams were added: the Redskins (1974), Raiders (1977), and Dolphins (1979). Pictured here is the 1977 Foster City Lions team. From left to right, they are (first row) Kevin Toombs, Paul Greco, Joe Lindsey, John Duttweiler, Danny Strauss, Mike Wilson, and Chris Mossino; (second row) Jim Enes, Robbie Walker, Dave Serne, Kamran Abbaszadeh, Kirk Dahl, and Greg Vella; (third row) Chuck Bartell, Steve Johnson, Gary Hingst, Ralph Cavanna, John Lappin, Mike Tamburina, and Mike Williams; (fourth row) Ted Bibbes, John Labbie, Tony Gladney, Brian Spangenberg, Tom Curry, Tom Fowler, George Hammond, and Tom Tuipulotu; (fifth row) John McFadden, Andy Smith, Tony Contestabiley, Pat Mila, Doug Dagan, Marc Williams, and Chris Voggel; (sixth row) Ted Saberi, Coach Alton Fuller, Art Jarrett, Coach Wayne Witter, D. Stewman, Head Coach Carl Smith, John Botto, Coach Wayne McFadden, Carlos Smith, Coach Steve Jones, Tom Anaya, Coach Jack Allen, and Charles Barringer. (Courtesy of Lucy Williams.)

Lynn Swann moved to Foster City in 1969 with his family and was a star wide receiver and quarterback at Serra High School. He continued playing wide receiver at USC, where he became known for his spectacular catches and leaping ability. Swann was named to the All-American Team in 1973 and was a first-round draft choice of the Pittsburgh Steelers the following year. Swann finished his career with 51 touchdowns, was a three-time All-Pro, and was voted MVP in Super Bowl X. Swann is a member of the San Mateo County Hall of Fame, the College Hall of Fame, and was elected in 2001 to the National Football League Hall of Fame. He currently works as a sportscaster. (Courtesy of Willie and Mildred Swann.)

Another pro-football player to come out of Foster City, David Binn played football at San Mateo High as a tight end. At U.C. Berkeley, he was a long snapper and tight end and graduated with an unusual degree: Ecology and the Social System. He joined the San Diego Chargers in 1993 and continues to this day as the premier long snapper in the National Football League. He also heads the David Binn Foundation. (Courtesy of Robert and Linnell Binn.)

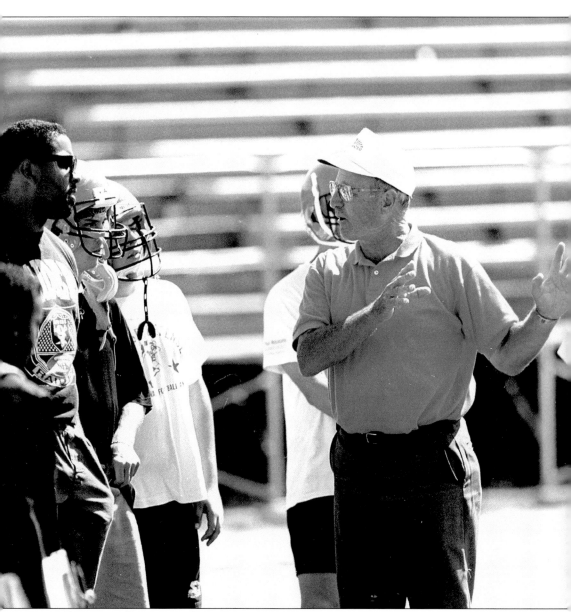

Rolfe "Buz" Williams moved to Foster City in 1969 beginning an extraordinary teaching career that would span more than four decades. During his illustrious coaching career at San Mateo High School, Williams won 201 football games and has been named the MPL and PAL coach of the year nine times. His 1980s teams were among the finest in the Central Coast Section, resulting in his being named Northern California High School Coach of the Year in 1986. He was also the San Jose Mercury's Peninsula Coach of the Year during those years, as well as Honor Coach of the Year for the Central Coast Section. In addition to coaching football, Williams also served as the golf coach at San Mateo High for over 30 years. Williams is now a member of the San Mateo County Hall of Fame and serves as a mentor to other high school football coaches. (Courtesy of Lucy Williams.)

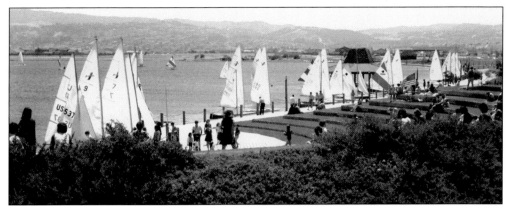

With its 16 miles of navigable waterways, Foster City is a boater's paradise. On any given week-end, one could look out on the lagoon and see colorful sailboats dotting the waterways. Foster City even has its own Yacht Club, The Island Sailing Club, which hosted annual regattas. Sailing was all the rage during Foster City's early years, as residents made full use of the city's unique lagoon system. This image, taken at Central Park (now Leo Ryan Park) in the late 1960s, captures the aquatic enthusiasm. (Courtesy of the Mooney family.)

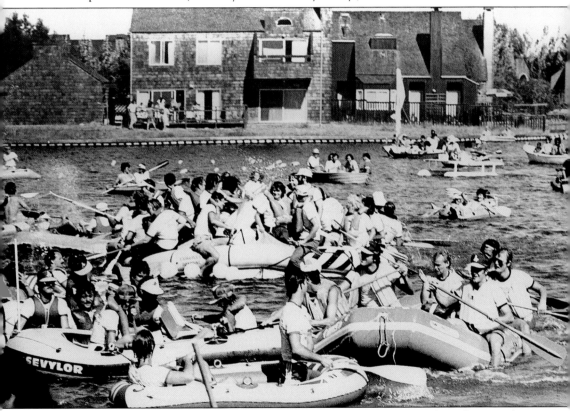

For years, The Rubber Ducky Raft Race drew scores of residents and non-residents from neighboring communities to participate in a fun and wacky aquatic "competition" held in late summer. Participants brought vessels of all kinds to the lagoon adjacent to Edgewater Place Shopping Center and paddled about in one last event of the season. (Courtesy of the Foster City Chamber of Commerce.)

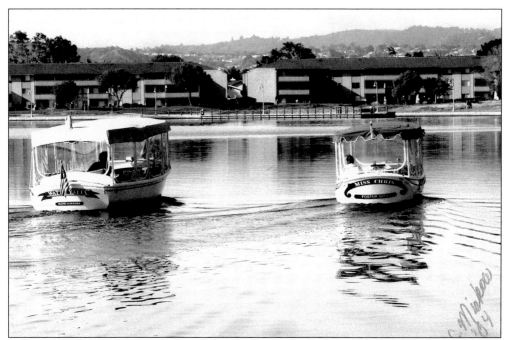

By the late 1980s, the sailing craze was displaced by the windsurfing craze, and by the mid-1990s, the wind-driven boat craze had given way to a more leisurely form of boating, electric powerboats known to the residents as "Duffys." In this picture, two residents enjoy a leisurely outing on the lagoon. (Courtesy of Catherine Miskow.)

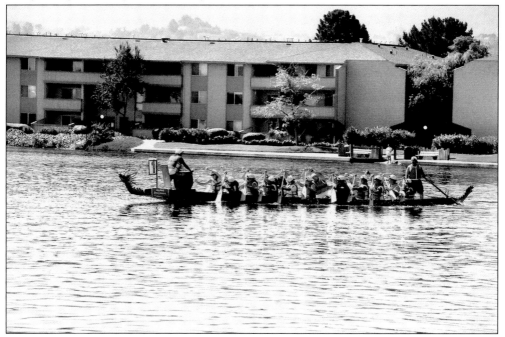

The Foster City lagoon attracts all types of water-sport aficionados. Every year, the Bay Area Dragon Boat group, made up of members from all over the Bay Area, holds its annual race in the lagoon. (Photo by Kurt Dotson, courtesy of Foster City Chamber of Commerce.)

Island Sailing Club

P.O. BOX 4066
FOSTER CITY,
CALIFORNIA 94404

1979 MEMBERSHIP RENEWAL

MEMBERSHIP DATA

Name (please print)

Street

City Zip Code

Telephone

Boat Class Sail No. Name

Spouse

Child(ren) Birth Date

RENEWAL FEES
 Enclosed please find my check to the Island Sailing Club in the following amount:

___ Adult or family renewal...............$18
___ Junior (17 yrs. or under).............$13
___ New member initiation................$10
___ Annual race subscription (summer
 series, regattas and winter series)...$30
___ B. O. A. T. (political lobby)............$__
 Total enclosed............$___

COMMITTEE ASSIGNMENTS
 I would also like to pitch in and work on one or more of the following committees:

___ Social ___ Port Captain
___ Hospitality ___ Mainsheet
___ Port O'Call Display Case ___ Special Projects
___ Publicity & Public Relations ___ Telephone Committee
___ Race Planning

Signature Date

Pictured is a membership renewal form from one of Foster City's earliest recreational organizations, the Island Sailing Club, which was headed by the late James Moore. (Courtesy of the Moore family.)

The Foster City Bikeway/Pedway, running north from Redwood Shores along Beach Park to Third Avenue in San Mateo, affords fitness opportunities such as walking, jogging, cycling, and rollerblading in a safe atmosphere away from auto traffic. In this photograph, Foster City police officer Martin Vaz leads the annual community bike ride along the trail. (Courtesy of the Foster City Chamber of Commerce.)

When the old San Mateo Bridge was demolished in 1969, a portion of the approach from Third Avenue was left standing. That remnant, known as the Werder Fishing Pier, was a popular site for anglers from all over the Bay Area to try their luck. (Courtesy of the Foster City Chamber of Commerce.)

This promotional brochure, issued by the Parks and Recreation department, details the different activities and routes along the pedway. (Courtesy of Foster City Parks and Recreation Department.)

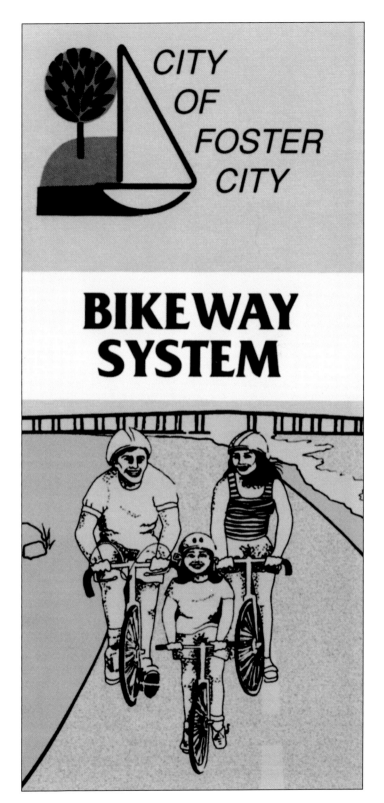

CITY OF FOSTER CITY

BIKEWAY SYSTEM

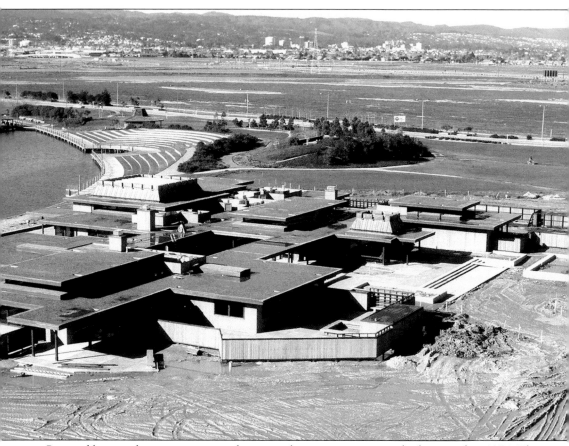

Pictured here under construction is the original recreation center, which opened in 1974. The small facility featured a day care center and large rooms where classes could be held. As the recreation center expanded its offerings, it became clear that a new, larger facility would be needed. Rather than tearing down the original structure, the existing building was modified and expanded. (Courtesy of the Foster City Chamber of Commerce.)

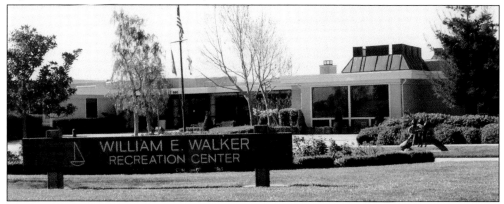

The new facility features special complexes for all ages including a senior citizen's wing, a youth and teen center, an enlarged daycare-preschool facility, and expanded classrooms. Opened in 1998, the center was christened the William Walker Recreation Center, in honor of one of the city's early mayors who lobbied for more recreational space. (Photo by Linda Gargiulo.)

Seven

COMMUNITY ACTIVITIES

As with any city, Foster City hosts a variety of community activities, fostering neighborly bonds. In addition to the requisite groups such as the Scouts and the service clubs, Foster City is also home to many ethnic clubs, reflecting the diversity of the city's social fabric; among these clubs are the Association of Black Residents, the Chinese Club, and the Filipino American Association. The Filipino American Association began in 1979 and included founders Olympio and Ruth Galon, Carlito and Becky Guerrero, Andy and Zaida Saberi, the Bailey family, the Gamboa family, the Nario family, and Nympha and Amor Paraso.

Service clubs, such as the Rotary and the Lions, help to promote community service among the adults just as the scouts foster this spirit in the youth.

Foster City unofficially marks the beginning of summer with its annual Arts and Wine Festival, sponsored by the Chamber of Commerce, the City of Foster City, the Rotary Club, and local arts groups. The huge festival was originally two separate events, Foster City's Birthday Party which marked the anniversary of incorporation, and the Arts and Wine Festival. Foster City's Birthday Party was a true civic pride event, with a huge 15-foot birthday cake for all the residents to share. The Foster City Arts Council also sponsored a "history tent," displaying artifacts from the history of Foster City's founding. In 1983, the Foster City's Birthday Party and the Arts and Wine Festival fell on the same weekend and have since been merged into a two-day celebration of the city's heritage. For several years, the event was marketed as "In Celebration of Foster City's Birthday," but in recent years, the subtitle has been dropped. The two-day festival, a tradition in the city since 1971, features a full carnival, performances by local performance groups, and artists from around the country displaying their wares. Another summertime tradition is the Lion's Club Fourth of July bash founded in 1967, dates back to before the city's incorporation. The two day event kicked off with a pancake breakfast in the park, followed by a parade through the city, musical performances, and the dazzling fireworks finale over the lagoon. With its colorful floats lining East Hillsdale from the Port O'Call shopping center down to Ryan Park, Foster City could have passed for Anytown, USA. In recent years, the event has scaled back to one day, and the parade has been reduced to a small group of tricycle riding, wagon toting children showing off their patriotic spirit by marching through the park, but the community spirit fostered by the event lives on.

As with any community, religion and spirituality help to strengthen the bonds among the residents. Foster City has long been ecumenical, reflecting the diverse nature of the community's rich spiritual life. Foster City features a synagogue, a Catholic Church, one Episcopal Churches, and a church of Latter Day Saints. Most recently, a multi-denominational interfaith church named Central Peninsula Church joined the community.

Members of the Island United Church are shown serving breakfast on July 4, 2003. This Independence Day pancake breakfast has become an annual tradition of the church, going back to the mid-1970s. The breakfast traditionally is the kickoff to the Fourth of July Lions Club celebration in Ryan Park. (Courtesy of Island United Church.)

On Sunday, September 23, 2001, the American Repertory Theatre Ballet performed *Swan Lake* at Ryan Park. Here is Swan Queen Odette, played by Tina Bohrstedt. This performance took place only 12 days following the tragic events of September 11th. A moment of silence was held at the beginning of the show, and donations were collected for the Red Cross. (Courtesy of Larry Staley.)

The Foster City Lions Club had its first organizational meeting in November 1966, and was chartered on April 15, 1967. The organization has grown steadily since and continues to serve the community with a myriad of activities, including the annual Fourth of July pancake breakfast and a fireworks show at Ryan Park. Other events include the Blood Drive, White Cane Project for Sight, Eye Foundation, and a health fair to provide free flu shots for seniors. Programs are not limited to only seniors. Youth Week encourages Foster City students to become involved with government and community affairs, and the Youth Exchange Program allows foreign youths to visit Foster City while Foster City youths visit another country. This exchange program began with Japan and now involves students from countries around the globe. (Courtesy of the Mooney family.)

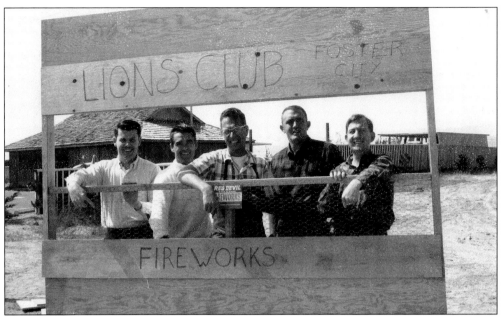

The Lions Club's first big sponsored effort was a Fourth of July celebration. Among the many sub-events were the Red Devil fireworks fund-raiser. Pictured here, from left to right, are Wayne McFadden, Mel Horne, Charles (Chuck) Archer, Mike Mooney, and Jan Vandenberg. This stand was located on the corner of Foster City Boulevard and Chess Drive. (Courtesy of the Mooney family.)

The Fourth of July parade, pictured here in the late 1960s, passed along Hillsdale Boulevard right in front of the Foster and Wilsey-Ham buildings on its trek through the city. The July Fourth ceremonies remain an annual tradition and are now co-sponsored by the Lions and the City of Foster City. (Courtesy of the Mooney family.)

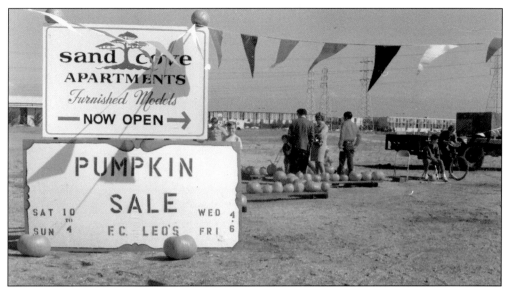

The Lions Club also sponsored a youth chapter called the Leo's, which functioned separately from the main club. The group, designed for grade school through high school, participated in various events such as the pumpkin sale shown in this picture. The sale was held on the corner of Hillsdale and Shell Boulevards, the site of the current library. (Courtesy of the Mooney family.)

Pictured here is the Foster City Lions Club mascot with Public Safety Officer John Dineen. Interestingly enough, the Lions Club functioned as an adjunct governing body for Foster City, as many of its members were also on the Estero Board, which was the governing board prior to incorporation. (Courtesy of the Mooney family.)

This Wildlife Refuge sign was erected in October 1976 along the bike path near Beach Park and Foster City Boulevards. The Foster City Lions Club, working together with the Bicentennial Wildlife Project Committee, raised funds for tree planting, levee improvements, as well as the preservation of the wildlife habitat in that area. Pictured, from left to right, are Dean Hobbs, Albert Bergeron (Chairman of the Bicentennial Wildlife Project Committee), Ron White, and an unidentified individual. (Courtesy of Dean Hobbs.)

The Lions sponsored Christmas tree sales to raise money for community projects. This picture from December 1972 shows, from left to right, Jim Cvengros, Joe Campbell, and Doug Cameron setting up shop at the corner of Hillsdale and Shell Boulevards. At the conclusion of the holidays, tree purchasers could have their trees disposed in a giant bonfire held on the same site. Many early residents recall the spectacular flames reaching high into the night sky. (Courtesy of Roger Chinn.)

This flyer from 1973 advertises an Easter egg hunt sponsored by the Lions Club. Note the mention of the location, the site of the proposed high school. (Courtesy of Roger Chinn.)

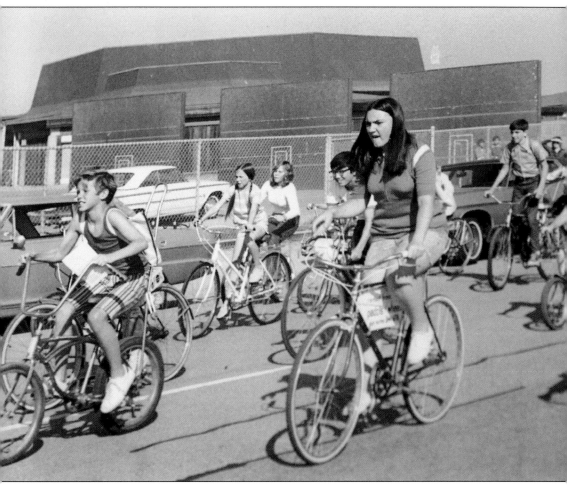

In front of Bowditch Middle School, bikers prepare to depart on the Lions Club–sponsored Bikeathon for Sight on October 7, 1972. Sponsors pledged money for each mile ridden by participants in the 30-mile ride, with the proceeds used for testing, detection and prevention of sight handicaps. (Courtesy of Roger Chinn.)

For a few years, the Foster City Jaycees sponsored a fundraiser carnival held at the corner of Shell and Hillsdale Boulevards. This picture was taken at the inaugural carnival on October 9, 1977. The first annual Jaycee carnival project chairman, George Kikuchi, spearheaded the effort. The Foster Building can be seen in the back of the picture on the other side of Hillsdale Boulevard. At the time this location was open land but is now the site of the current Foster City Library. (Courtesy of Larry Staley.)

The Girl Scouts have played an active role in Foster City since the city's incorporation. The Girl Scouts participate actively in many community activities. In this photo from 1988, Foster City Girl Scout troop 1193 performs at the Arts and Wine Festival. Pictured, from left to right, are Catherine Miskow, Melissa Smith, Ryanne Harris, Renee Faraudo, Shaina Johnson, Erica Torgerson, Jody Winchester, and Maggie Shotola. The girls ranged in age from 10 to 13. (Courtesy of Catherine Miskow.)

The Foster City Chorus, founded in 1992 by Fred deBoer, has grown from a small, local community chorus to a vibrant and versatile performance group, singing a wide variety of musical styles, ranging from Renaissance classical to Broadway to Top 40. The group consists of the chorus and a smaller performance chorale known as "Heart and Soul." Both groups perform two concerts annually and have developed national renown, performing at such venues as the Dallas Choral Fireworks in Texas, the White House, SBC Park in San Francisco, and Carnegie Hall in New York. (Courtesy of Foster City Chorus/PMAA.)

FLAIR, a black women's civic and social organization, was formed in 1968 and remained active until 1985. The main purpose was to raise money to fund scholarships for black students in the San Mateo Union High School District. Their very popular yearly Ball drew 400 to 500 people from all over the Bay Area. Black junior year students actively competed for the host and hostess positions at the Ball. Students learned social graces, how to entertain, and skills for success in the workplace. The Ball was elegant, and the 3 a.m. breakfast served was a special bonus. Pictured here, from left to right, are (front row) Millie Swann, Erma Prothro, Ruth Payton; (back row) Belle Gomez, Carolyn Thompson, Mettie Range, Jean Tatum, and Laurie Galloway. Former Foster City FLAIR members not pictured are Beverly Valentine, Joan Des Boines, Vicki Gafner, Dorris Stewart, and Barbara McKee. (Courtesy of Erma Prothro and Lucy Williams.)

Carl and Cleon Smith, who were the second black residents to move into Foster City, casually began the Foster City Association of Black Residents in 1967. When selling homes in Foster City, T. Jack Foster Sr. refused to include the clause about not selling homes to people of color, a clause that was common in many communities at that time. This group served to welcome new black families into the community and provided a social and civic connection. Robert and Fannie Peagler, John and Erma Prothro, Virgil and Helinda Morrow, Jim and Alice Lawrence, and Bill and Doris Stewart formalized the group in 1970. The group continues to provide the very popular barbeque booth at the Fourth of July festivities in Ryan Park. Pictured here in 1970, signing the formal papers for the organization's founding are, from left to right, Virgil Morrow, Helinda Morrow, Robert Peagler, Fannie Peagler, Alice Lawrence, Jim Lawrence, and John Prothro.Some of the early members were Bill and Doris Stewart, John and Erma Prothro, Bob and Fannie Jo Peagler*, Sol and Leola McCollough, Carl* and Cleon Smith, Alex* and Nova Alexander, Chet and Ada Lax, Ernie and Marie Davis, Woody and Betty Andrews, Ralph and Laurie Galloway, Lou and Belle Gomez, Hillary* and Artie Bennett, Elridge and Marion* Gardner, Ray and Yvonne Gattis, Vera and Leonard* Pitts, Jim and Teena Burris, Charles and Earline Douglas, Ray* and Beverly Valentine, Lenny* and Virginia Carter, Willie and Millie Swann, Evelyn Taylor, Dave* and Harlene Gladney, Arthur and Beulah Smith, John* and Fannie* Merida, Dick and Margaret Fagetti, Lionel and Kathy Stewart, Adam and Barbara McKee, The Trotters, Mary Hollis, Ed Stringer,* Sharon Edwards, Fritz and Faye Williams, Henry* and Mary Evans, Arthur and Jessie May, Henry and Barbara Adley, Ollie and Mary Pattum, Jim and Alice Lawrence, Bill and Carrie Cox, Rev. Rufus* and Helen Cooper, Eunice Cooper, Murrell and Barbara Moorhead, Ted* and Gwen Owens, Joe Ellis, Charles* and Mildred* Mott, The Des Boines, Mike Rosen, Jim and Sue Martin, George* and Jeanette Bell, Ron Allen, Loretta Hall, Clara Barrett, Herb and Alma Blanchard, Dan and Lucretia-del Broussard, Stan Casher, Allen and Barbara Conway, Grover Davis, Ron and Maxine Davis, Alton Fuller, Jacquelyn Green, Bob and Joanne Griffin, Don and Janette Greer, Fred and Joan Hopkins, Earl and Ray Williams, Sy Houston, Thaddeus and Colette Norman, Jesse McElroy,* Rev. Arthur and Leola Jarrett, Sam and Della Johnson, Ralph and Mona Simpson. (Courtesy John and Erma Prothro, Bill Stewart, Bob and Fannie Peagler, Lucy Williams.)

*=Deceased.

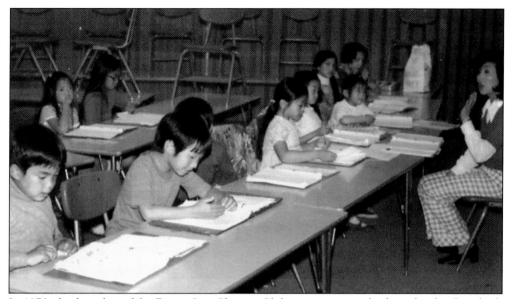

In 1972, the first class of the Foster City Chinese Club met once a week after school at Bowditch Middle School. The goal was to introduce Chinese children to Cantonese, Chinese culture, and traditions. Rose Lum, the first teacher, is shown instructing a class in 1974. Besides Rose, Yvonne Wong, Jane Lee, and Amy Lee have taught these classes over the years. (Courtesy of DeeDee Chang, Foster City Chinese Club.)

It was in 1971 that the growing Foster City community included a number of residents of Chinese ancestry. Thereafter, a group of new and old friends organized to develop a Chinese Language School. In order to provide continuous support for the school, the FCCC was founded in 1973 with the objective of promoting better understanding of the language, culture, and traditions of the Chinese heritage. Through the years, the club developed a great number of activities and participated in community events, many becoming an integral part of the Foster City community, including Toys for Tots, Foster City Library, Asian American Donor program, Chinese New Year parade, Arts and Wine festival, golf tourney, community bingo, July 4th celebration, youth club, junior youth group, Kung Fu and Tai Chi classes, scholarship program, international festival, Chinese cultural center activities, Joy Luck Club events, ballroom dance workshop, tennis tournament, and was one of the original sponsors of the dragon boat race. In 1996, the Foster City Chinese Club sponsored a float in the San Francisco Chinese New Year parade. The float featured a slogan of "The Land of Wind and Water." Here, television celebrity Rick Quan, two members of the Foster City Ballet School, and former mayor Roger Chinn are shown riding on the float. San Francisco Mayor Willie Brown later recognized the efforts of the team building the float. (Courtesy of Joyce Chinn.)

Beginning in 1968 and running through 1986, The Miss Foster City Pageant gave young women the opportunity to develop confidence and poise. In the early years, the pageant was sponsored by the Lions Club, and later by Vicki and Lee Smith, the Jaycees, the City of Foster City, and various other organizations. Winners would later represent Foster City as goodwill ambassadors, and were rewarded with cash scholarships, wardrobes, and other gifts. Past pageant winners were: 1968 Lynn Meihofer, 1969 Susanne Folen, 1970 Jill Olson, 1971 Margaret Bates, 1972 Patricia Shelton, 1973 and 1974 Hillarie Allison, 1975 Cathy Lucchesi/ Stella Joyce, 1976 Kelli McKenney, 1977 Julie McKenney, 1978 Cindy Casey, 1979 Elke Meyer, 1980 Vanessa Sligar, 1981 Wendi Allen, 1982 Gina Pericolosi, 1983 Amber Paquette, 1984 Wendi Bagby, and 1985 Paige Lesniak. Pictured here are Dr. Peter Freund and his daughter, 1986 winner Lisa Freund. (Courtesy of Katie Stephens.)

The Foster City Arts and Culture Committee is pictured here in the art gallery of the Recreation Center following their February 15, 2002 yearly retreat. Pictured are Dea Grut, Evelyn Long, Larry Staley, Jennie Floyd, Jonathan Korfhage (Parks and Recreation Committee liaison), Anita Zacherl, and Kenny Huo. The Arts and Culture Committee is just one of several citizen-staffed advisory committees. These advisory groups started in the 1970s and have long played an important role in helping to shape community policies. Today's advisory committees include committees on auditing, education, information technology, noise abatement, parks and recreation, planning, senior citizens, traffic, youth advisory, and of course, arts and culture. The Arts and Culture Committee initially sponsored the Foster City Historical Society. (Courtesy of Larry Staley.)

In 2003, Parks and Recreation, in conjunction with the Foster City Rotary Club, presented the first Oktoberfest, held in Leo J. Ryan Park. The event included German food, beer, music, a car show, a pumpkin sale, train rides, and other entertainment. (Courtesy of Marcia Cohn-Lyle.)

In this 2001 photo, Jeremy Hill and Adam Lee of Boy Scout Troop 175 are distributing Foster City Chamber of Commerce directories. Troop 175 was the first troop founded back in 1966 and was first chartered by the Foster City Community Association, then the Bowditch PTA, and most recently the Rotary Club. Some 1,000 boys have been associated with the troop over those 38 years, with some 60 having earned their Eagle Scout award. Boy Scout Troop 47 began in 1967 when Steven L. Darling, pastor of the Methodist Church, set up the troop's charter with the church as the original sponsor. The "Dads of Troop 47" later took over, and the Rotary Club currently sponsors the troop. Some 69 scouts have earned their Eagle Scout award from Troop 47. Current Foster City mayor Rick Wyckoff was a former Troop 47 scoutmaster. A third troop is chartered through the Church of Jesus Christ of Latter-day Saints. Troop 142 was originally chartered in 1951 to serve boys in the San Mateo area, but Foster City became home to the troop in 1978 when the LDS church building was completed at the corner of Catamaran Street and Shell Boulevard. (Courtesy of Larry Staley.)

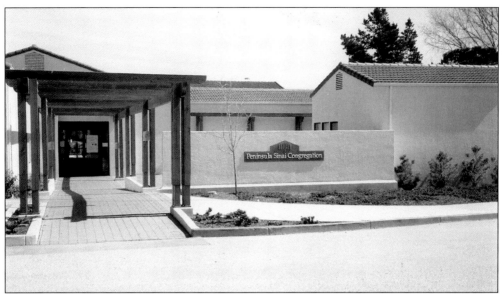

The Peninsula Sinai Congregation was first formed in 1966. They originally met at a church in San Mateo and then at the Jewish Community Center in Belmont. The congregation moved to Foster City in 1973 and met at various locales while their new synagogue was under construction. The present synagogue, pictured here, opened in 1979. Of the early pioneers who helped start the congregation, special mention is made of Col. David J. Reina, who served in World War II in both the Pacific and European theatres of war and after the war served on assignment to the 6th Army at the Presidio in San Francisco. His leadership helped establish the congregation serving as the first president, but also as rabbi and cantor when needed in those early years. (Courtesy of Linda Gargioulo.)

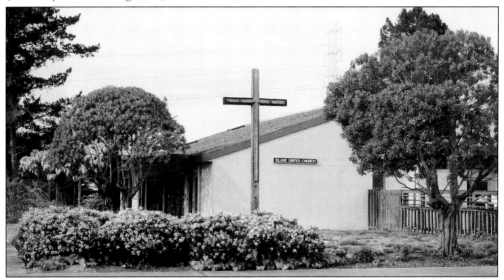

Island United Church was chartered in May 1969 and represented a new experiment in ecumenical life as a tripartite denomination, incorporating the United Methodist Church, the United Church of Christ, and Presbyterian Church U.S.A. The present building seen here opened in 1973 with the sanctuary added in 1977. Rev. Robert J. Kersey first served as pastor for the church from 1969 to 1977. (Courtesy of Lora Pallatto.)

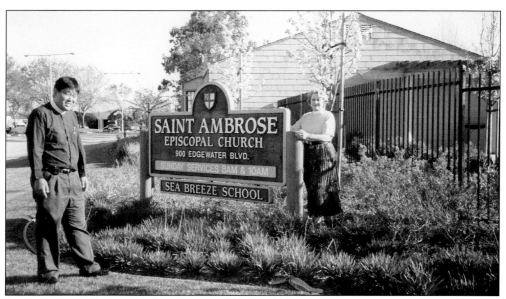

Saint Ambrose Episcopal Church, originally founded in 1963, moved to its present location at 900 Edgewater Boulevard in 1978. Under the leadership of Rev. Richard Rowe, who served from 1974–1982, Saint Ambrose developed both the congregation and its Sea Breeze School, a pre-school, kindergarten, and after school program that has served hundreds of children and their families since its inception in 1978. St. Ambrose Episcopal Church and Sea Breeze School is currently served by Rev. David Ota and Rev. Christine Leigh-Taylor who are pictured here. (Courtesy of Linda Gargioulo.)

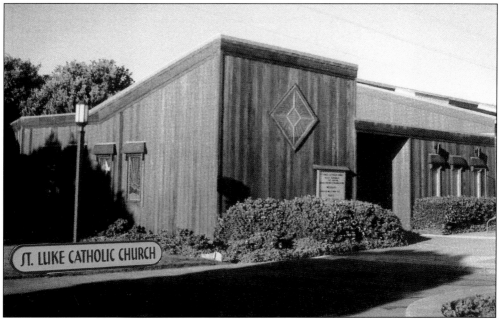

St. Luke Parish was founded by Rev. Robert G. Stadler in 1970. The congregation oversaw the construction of the church, which was dedicated in June of 1976. Today, the parish provides worship and educational programs for approximately 920 Catholic families. (Courtesy of St. Luke's congregation.)

The Church of Jesus Christ of Latter-day Saints' Foster City Chapel was built in 1978. It currently serves a congregation of approximately 1,000 members and supports many youth, women's, scouting, and adult organizations and activities. The first bishop of the ward was Foster City resident Grant Richards. Since then, other Foster City residents, including Rick Holbrook and Jim Hardy, have been called to serve as bishop of the ward. (Courtesy of Linda Gargioulo.)

Central Peninsula Church, a non-denominational church, was founded in 1967, and met for several years at Bowditch Middle School. Their present church, pictured here, opened in 1996. (Courtesy of Central Peninsula Church.)

Bayside Community Church offers Foster City citizens another place of worship. Originally known as Bayside Baptist Church, it was incorporated in the Bayview section of San Mateo in February 1962. The church was moved to its Foster City location at Beach Park and Tarpon in 1972. The new sanctuary pictured here was completed in 1987. The name was officially changed to Bayside Community Church in 1994. (Courtesy of Larry Staley; caption courtesy of Wilfred Gibo, Bayside Community Church treasurer.)

Hillbarn Theatre, the sixth-oldest continually operating community theatre in the United States, was constructed in 1968 on land donated by the Foster family. The theatre was initially directed by Robert Brauns and Sam Rolph. Upon its opening, theater critic Barbara Bladen wrote in the May 27, 1968 *San Mateo Times* that, "Pride mixed with nostalgia . . . at the opening of the new Hillbarn Little Theatre . . ." The Hillbarn Theatre had originally been founded as an outgrowth of the Peninsula Little Theatre, a community theater operated under the auspices of the Adult Learning Division of the College of San Mateo back in 1941. The theatre's original home was the chapel on the old Borel Estate in San Mateo. When the theatre was condemned to make way for construction of the Highway 92 overpass, it found a second home at the Carlmont Shopping Center where it was housed from 1962 to 1968. (Courtesy of Lee Foster, executive director, Hillbarn Theatre.)

This is the inside of the program for the first play ever shown at the Hillbarn Theatre in Foster City on May 27, 1968, *Dark of the Moon*. Note the long list of Hillbarn "Angels," whose contributions were so important to making the theatre a reality. The program included a warm welcome from the Foster Family delighting in the fact that Hillbarn is now a part of the cultural life of the community. (Program courtesy of Lee Foster, executive director, Hillbarn Theatre.)

Pictured here is the original cast of the play *Dark of the Moon*.

T. Jack Foster & Sons extend a warm welcome to the Hillbarn Theatre. All of us here in Foster City are delighted that Hillbarn is now a part of the cultural life of the community.

Foster City
THE ISLAND OF BLUE LAGOONS

This is a 1968 promotional welcome to the Hillbarn Theatre. The Foster family provided the land for the construction of the Hillbarn Theatre. (Courtesy of Bette B. Garcia-Martinson.)

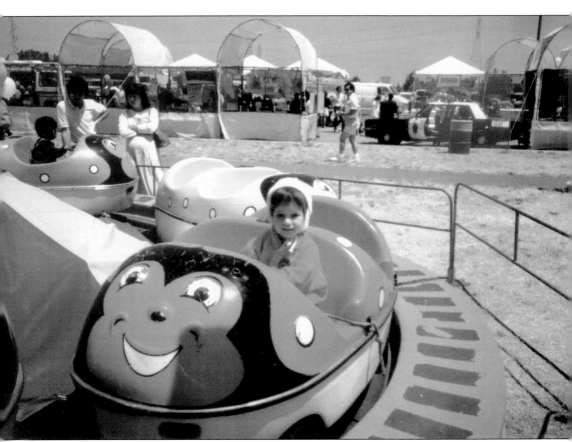

Another annual tradition is the Arts and Wine Festival. Co-sponsored by the Foster City Rotary Club, the City of Foster City, and the Chamber of Commerce, the event features local artists and street merchants selling and displaying their wares, along with a huge carnival at Leo Ryan Park. In 1983, the Arts and Wine Festival's date coincided with that of the Foster City Birthday Party, and the two events have since been consolidated into one, held every year on the first weekend in June marking the unofficial beginning of summer. The festival features booths of both commercial and nonprofit groups; live entertainment, great food, and special community oriented events in addition to the always-popular carnival. The festival started in the mid-1970s and occurs on the weekend after Memorial Day. In this photo, three-year-old Aaron Staley is enjoying his carnival ride on June 3, 1989. (Courtesy of Sharon Staley.)

Eight

FOSTER CITY: THEN AND NOW

By the early 1980s, Foster City had established itself as a reputable community and a venerable place to do business. The "big business" boom began in 1986 with the opening of both Foster City's first hotel and the Metro Center office and retail complex. With its larger, modern facilities, chain store retailers soon began moving in, forever changing the retail demographic of Foster City. The Metro Center complex, located across the street from Ryan Park, became the new "heart" of the city, and many of the "anchor" merchants, previously housed at the Port O' Call complex moved in to the Metro Center. And although Port O' Call continued to operate without its anchor stores, many of the smaller merchants found that they just could not compete with the big name merchants across town. Port O' Call was closed permanently in 1996 and demolished three years later, thereby closing a chapter of Foster City's history.

Even the landmark buildings, such as the Foster, Wells Fargo, and Wilsey-Ham complexes, were not immune to this forward progression. In 1998, the Foster Building and its sister buildings—the Wilsey Ham Building and the Wells Fargo Building—were demolished to make room for a new business complex owned by a well known technology company. The new complex, known as "Parkside Towers," opened in 2001.

While hackneyed sayings such as "Time marches forward" and "You cannot stop progress" appear apropos to larger metropolises, they somehow seem to bypass the smaller cities. The charm of small towns lies in their ability to move forward with the times, while keeping their quaint nature intact. Historically significant buildings remain standing even after their original occupants have moved on. And while some residents lament the loss of Foster City's small-town feel, others marvel at how the city has managed to move forward while never losing sight of the founder's original vision. Local artist Alvin Joe captures this essence of Foster City in his outstanding paintings of the community. Fittingly enough, a statue of T. Jack Foster Sr. stands in front of the clock tower at City Hall complex. He seems to be watching time march forward while marveling at his city's past.

This picture, taken in Gull Park on a summer day's day in the mid-1970s, clearly reflects the lifestyle of Foster City during that time. Many children are seen playing in the lagoon. The park is dominated by sand, with an obvious orientation to fun in the water. A portion of a floating platform for diving or sunning can be seen on the left. Also in view is one of the lifeguard chairs that stood so prominently in the park. The coveted city-hired lifeguard positions were sought by local teens. These lifeguards provided a safer environment at the parks. During the summer months, it was a special place where children could play all morning, come home for lunch, and return for the rest of the day. Children experienced a sense of freedom and independence that they do not have today. (Courtesy of Foster City Chamber of Commerce.)

Flash forward to this picture, taken on a bright autumn morning, October 15, 2004, from virtually the same angle as the picture above. The sand is far less prominent now. The former floating platform has been long gone, but now visible is a sign sticking up from the water. It reads, "Danger Drop Off Point." To the right, just beyond the border of this photograph, is newer playground equipment that complies with current child safety standards. Other amenities of today's park include picnic tables and the very popular walking path.

The original Foster City Library, completed in 1972, stood on the corner of Foster City and East Hillsdale Boulevards, adjacent to the city civic center. This one-room building featured a designated children's area, an adult section, and a reference desk. (Courtesy of the Foster City Chamber of Commerce.)

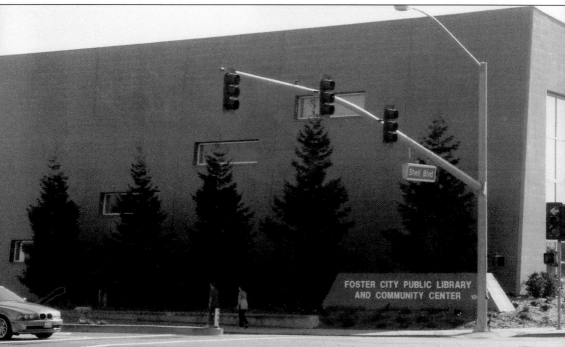

The old library was torn down in 1996 and a new facility was built on an adjacent lot. The new complex is over twice the size of the original facility and boasts a separate children's library and reference area. Adjacent to the library, but in the same complex, is a multipurpose community room. (Photograph by Catherine Miskow.)

Located on the same site as the library, the government complex consisted of the council chambers and the city hall. Opened on June 3, 1972, it meant that the fledgling city now had an official government seat.

Although the library had moved out of the complex in 1996, the city council still utilized the facilities until 2001, when the complex was demolished to make room for the new government center, shown here. (Courtesy of Catherine Miskow.)

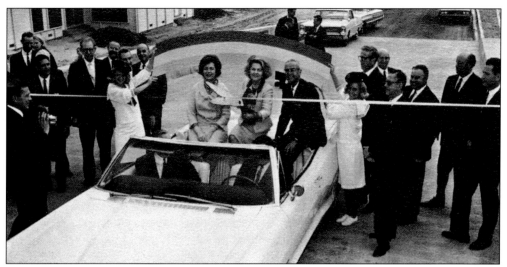

Joan Fontaine (center of car), star of stage and screen, was on hand to dedicate the new Rainbow Bridge in the spring of 1965. (Courtesy of Dean Hobbs.)

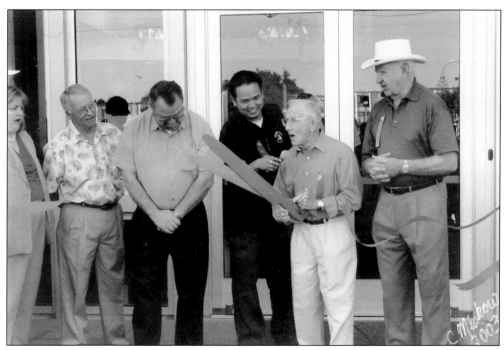

In this picture, Mayor Russ Harter cuts the ribbon, officially opening the new city hall complex. Pictured, from left to right, are Debrah Wilder, councilmember; Rick Wykoff, planning commissioner; Ron Cox, councilmember; Francis Mendoza, Parks and Recreation Department; Mayor Russ Harter; and Marland Townsend, councilmember. (Photograph by Catherine Miskow.)

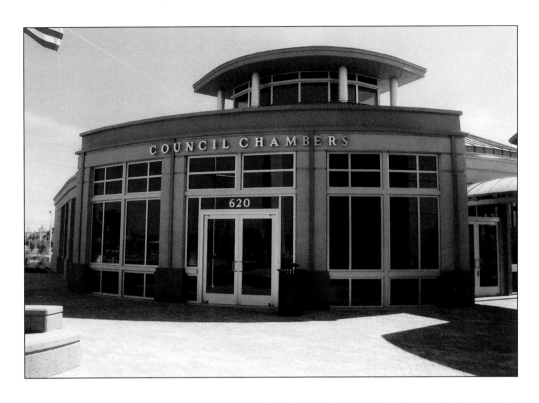

The Council Chambers building was completed and opened in November 2003, thereby marking the completion of the new government complex, shown in part below with the fire department. (Courtesy of Catherine Miskow.)

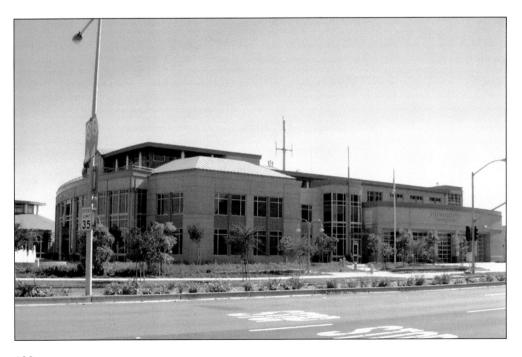

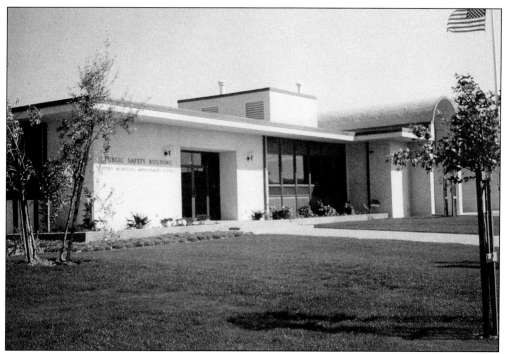

At the time of its founding, Foster City had a designated public safety department which combined the fire and police departments. The original Public Safety Building, pictured here, was completed in the late 1960s. (Courtesy of Foster City Chamber of Commerce.)

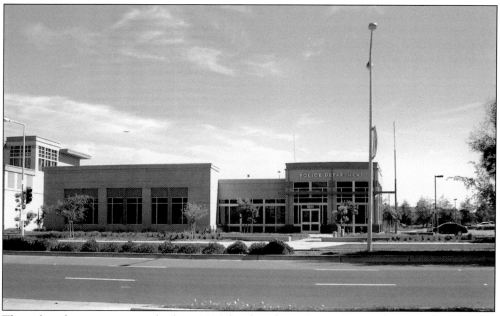

The police department was rebuilt in 1986, but less than 10 years later, it became clear that the facility was too small. As part of the 2003 inauguration of the city government complex, a new fire station and police station were completed. (Courtesy of Nevin Duerr.)

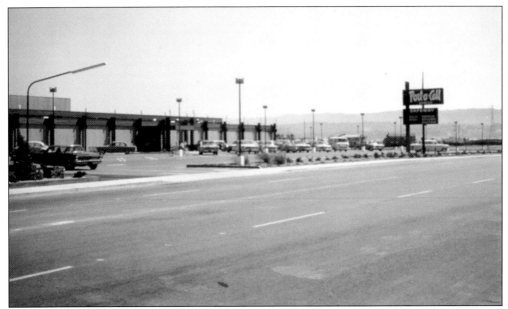

This is the original Port O' Call shopping center, pictured in the late 1960s. The primary tenant, Safeway, had outgrown its facility by 1985, and the following year, moved to the newly constructed Metro Center shopping and business complex. Changing times contributed to the demise of the neighborhood shopping centers at Port O' Call and Marlin Cove. (Courtesy of Foster City Chamber of Commerce.)

The Port O' Call shopping center continued to operate until 1997, when it was permanently closed due to lack of foot traffic. The complex was leveled in 2000 after 35 years and a series of low-rise apartment complexes were built on the site. Although the original boat garden was razed as well, there is still a dock where residents can park their boats for the day. (Courtesy of Nevin Duerr.)

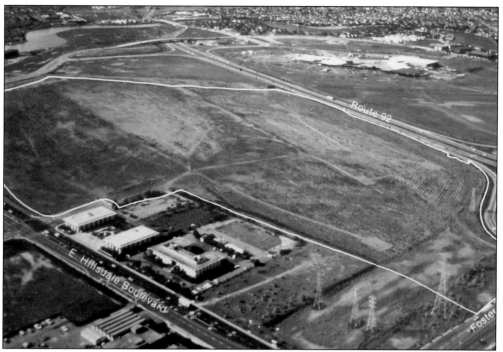

By the early 1980s, much of the residential developments had been completed, but a significant portion of land earmarked for commercial and residential use remained unchanged. By decade's end, townhouses and commercial projects, including a new Safeway shopping center and high-rises, had filled in the area. (Courtesy of the Mooney family.)

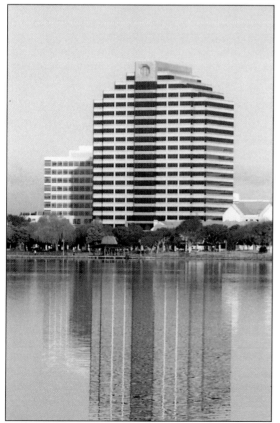

As business expanded in Foster City, the need for new business space grew proportionately. The Metro Center, completed in 1986, consists of a central office tower, surrounded by a retail complex. It was Foster City's first high-rise, and at the time of its completion, was the tallest building between San Francisco and Los Angeles. The tower has become one of the symbols of Foster City. (Courtesy of the Mooney family.)

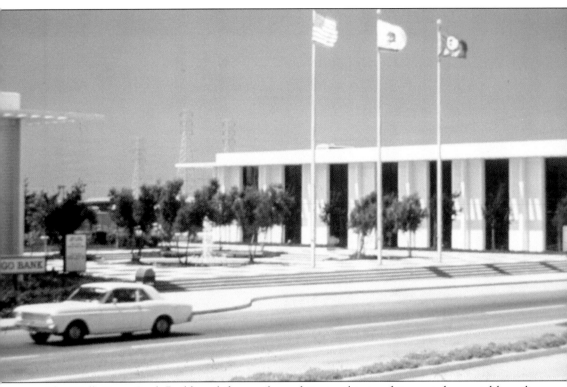

The Wells Fargo Bank Building, left, was the architectural twin of its next-door neighbor, the Foster Building, which housed T. Jack Foster and Sons' executive offices. On the opposite side of the Foster Building stood the headquarters of the engineering and architectural firm, Wilsey, Ham & Blair. (Courtesy of Foster City Chamber of Commerce.)

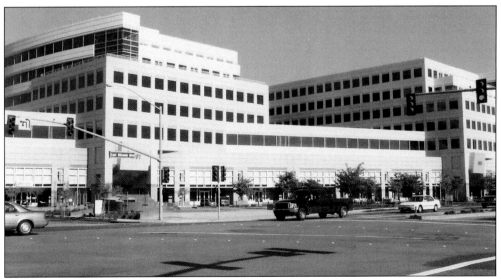

All three buildings were demolished in 1999 to make way for the new, larger Parkside Towers office complex completed in 2001 and houses office space, retail shops, and restaurants. (Courtesy of Catherine Miskow.)

124

A statue of the city's founder, T. Jack Foster Sr., stands watch over the new city government complex, a sentinel to the city's progress. T. Jack Foster Sr.'s vision of a master-planned community was ahead of its time and the city has most certainly grown far beyond what the original four Fosters had envisioned. (Courtesy of Catherine Miskow.)

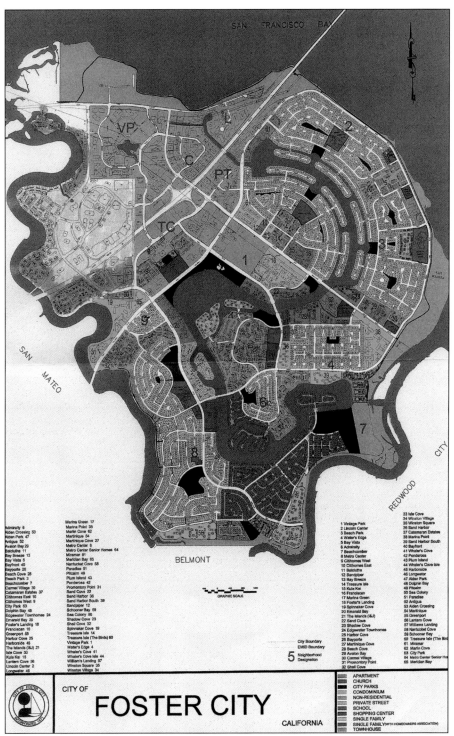

The following is the legend/list that appears within the map image:

Admiralty 6
Alden Crossing 53
Alden Park 47
Antigua 52
Avalon Bay 29
Balclutha 11
Bay Breeze 13
Bay Vista 5
Bayfront 40
Bayporte 26
Beach Cove 28
Beach Park 3
Beachcomber 7
Carmel Village 30
Catamaran Estates 37
Clithomas East 10
Clithomas West 9
City Park 63
Dolphin Bay 48
Edgewater Townhomes 24
Emerald Bay 20
Foster's Landing 18
Franciscan 16
Greenport 55
Harbor Cove 25
Harborside 45
The Islands (I&J) 21
Isle Cove 33
Kula Kai 15
Lantern Cove 56
Lincoln Center 2
Longwater 46

Marina Green 17
Marina Point 36
Martin Cove 62
Martinique 54
Martinique Cove 27
Metro Center 8
Metro Center Senior Homes 64
Miramar 61
Meridian Bay 65
Nantucket Cove 58
Paradise 51
Pitcalm 49
Plum Island 43
Ponderosa 42
Promontory Point 31
Sand Cove 22
Sand Harbor 36
Sand Harbor South 39
Sandpiper 12
Schooner Bay 59
Sea Colony 50
Shadow Cove 23
Shell Cove 32
Spinnaker Cove 19
Treasure Isle 14
Treasure Isle (The Birds) 60
Vintage Park 1
Water's Edge 4
Whaler's Cove 41
Whaler's Cove Isle 44
William's Landing 57
Winston Square 35
Winston Village 34

1 Vintage Park
2 Lincoln Center
3 Beach Park
4 Water's Edge
5 Bay Vista
6 Admiralty
7 Beachcomber
8 Metro Center
9 Clithomas West
10 Clithomas East
11 Balclutha
12 Sandpiper
13 Bay Breeze
14 Treasure Isle
15 Kula Kai
16 Franciscan
17 Marina Green
18 Foster's Landing
19 Spinnaker Cove
20 Emerald Bay
21 The Islands (I&J)
22 Sand Cove
23 Shadow Cove
24 Edgewater Townhomes
25 Harbor Cove
26 Bayporte
27 Martinique Cove
28 Beach Cove
29 Avalon Bay
30 Carmel Village
31 Promontory Point
32 Shell Cove

33 Isle Cove
34 Winston Village
35 Winston Square
36 Sand Harbor
37 Catamaran Estates
38 Marina Point
39 Sand Harbor South
40 Bayfront
41 Whaler's Cove
42 Ponderosa
43 Plum Island
44 Whaler's Cove Isle
45 Harborside
46 Longwater
47 Alden Park
48 Dolphin Bay
49 Pitcalm
50 Sea Colony
51 Paradise
52 Antigua
53 Alden Crossing
54 Martinique
55 Greenport
56 Lantern Cove
57 Williams Landing
58 Nantucket Cove
59 Schooner Bay
60 Treasure Isle (The Bird
61 Miramar
62 Martin Cove
63 City Park
64 Metro Center Senior Ho
65 Meridian Bay

City Boundary
EMID Boundary

5 Neighborhood Designation

GRAPHIC SCALE

BELMONT

SAN MATEO

REDWOOD CITY

SAN FRANCISCO BAY

CITY OF

FOSTER CITY

CALIFORNIA

APARTMENT
CHURCH
CITY PARKS
CONDOMINIUM
NON-RESIDENTIAL
PRIVATE STREET
SCHOOL
SHOPPING CENTER
SINGLE FAMILY
SINGLE FAMILY (WITH HOMEOWNERS ASSOCIATION)
TOWNHOUSE

The capacity for the city was set at 35,000 and the current population is approximately 30,000. This map indicates that the city is fully developed and residential and commercial properties have been completed. (Courtesy of Diane Daniels.)

Foster City maintains a unique balance between preserving its heritage from the past 40 years and looking to the future. This photograph of a painting by local artist Alvin Joe envisions the city of the future. (Courtesy of Alvin Joe.)

The Foster City Historical Society was organized to promote an understanding and support of the history of Foster City, and has and will continue to carry out that mission for its citizens. We are indebted to Arcadia Publishing for having extended the opportunity to us produce and publish this book as a most important milestone in this quest.

ACKNOWLEDGMENTS

Foster City is young. We are fortunate that for the purposes of this book, the vast majority of pictures representing Foster City only had to span the past 40 years. While we wish we had more pictures of the former Brewer Island, we are thankful to all of those who contributed pictures and narrative covering that time period.

We are indebted to the efforts of the members of the Foster City Historical Society, in particular Diane Daniels, Nevin Duerr, Catherine Miskow, Larry Staley, Katie Stephens, and Lucy Williams, without whose dedication and hard work, this book would not have been possible. We especially want to thank the publishing staff of Arcadia Publishing, and in particular, Mr. John Poultney, whose consistent input was deeply appreciated throughout production of this book.

Finally, we very much want to thank T. Jack Foster Jr. for his wise counsel and input that were so invaluable to all of us. May this book serve as a legacy to all of the Fosters, and particularly T. Jack Foster Sr., whose vision and commitment, were what after all, made Foster City become a reality.

CONTRIBUTORS

Mr. Don Aron
Robert and Linnell Binn
Burlingame Star-Register
Joyce Chan
Jo Ellen Chew
City of Foster City
Roger Chinn
Audubon Elementary School
Bowditch Middle School
Brewer Island Elementary School
John Dineen
Charles Douglas
Leo Duerr
Foster Enterprises
The Foster Family
T. Jack Foster Jr.
Foster City Chamber of Commerce (Pres. Carol Torgerson)
Foster City Elementary School
Foster City Fire Department
Foster City Historical Society members
 Richard Bennion, Lee Bray, Marcia Cohn-Lyle,
 Diane Daniels, Nevin Duerr, Bette B. Garcia-
 Martinson, Joan Hollingsworth, Catherine Miskow,
 Shawn Mooney, Larry Staley, Katie Stephens,
 and Lucy Williams
Foster City Lions Club
Foster City Police Department
Foster City Rotary Club

Anne Fuller
Richard Grant
The Hillbarn Theatre
H. Dean Hobbs
Alvin Joe
Ralph Lomele
Helen Kennedy, Island United Church
Fire Marshal John Mapes, Foster City Fire Department
David McKean
Ken Miskow
The Mooney Family
Dean Noble
Rev. David Ota, St. Ambrose Episcopalean Church
Amor and Nympha Paraso
Bob and Fannie Peagler
John and Erma Prothro, Foster City Association of Black Residents
Charles Royce, Peninsula Central Church
Ed Schuler
Serra High School
Bill Stewart
Willie and Mildred Swann
San Mateo County Times
Sgt. Scott Welch, Foster City Police Department
Buz and Lucy Williams
Wilsey & Ham